KU-594-403

THE AUTHOR

Pierre Louÿs (1870–1925) was influential in symbolist circles, but was subsequently overshadowed by his prestigious friends: Apollinaire, Mallarmé, Gide, Valery, Debussy and Wilde (who dedicated *Salomé* to him and said of Louÿs: 'he is too beautiful to be a man and should be careful of the gods').

An important critic, poet and novelist in his day, his reputation now rests on *The Woman and The Puppet*, one of the great novels about obsessive love.

THE TRANSLATOR

Jeremy Moore was born in 1968 and after reading History at Reading University travelled widely in Europe, Africa, India and South America before settling in France. He studied French and Spanish Literature at the University of Toulouse and is now a freelance translator and editor.

institut français

French Literature from Dedalus

French Language Literature in translation is an important part of Dedalus's list, with French being the language *par excellence* of literary fantasy.

Séraphita – Balzac £6.99
The Quest of the Absolute – Balzac £6.99
The Experience of the Night – Marcel Béalu £8.99
Episodes of Vathek – Beckford £6.99
The Devil in Love – Jacques Cazotte £5.99
Les Diaboliques – Barbey D'Aurevilly £7.99
Spirite (and Coffee Pot) – Théophile Gautier £6.99
Angels of Perversity – Remy de Gourmont £6.99
The Book of Nights – Sylvie Germain £8.99
Night of Amber – Sylvie Germain £8.99
Days of Anger – Sylvie Germain £8.99
The Medusa Child – Sylvie Germain £8.99
The Weeping Woman – Sylvie Germain £6.99
Infinite Possibilities – Sylvie Germain £8.99
Là-Bas – J. K. Huysmans £7.99
En Route – J. K. Huysmans £7.99
The Cathedral – J. K. Huysmans £7.99
The Oblate of St Benedict – J. K. Huysmans £7.99
The Mystery of the Yellow Room – Gaston Leroux £7.99
The Perfume of the Lady in Black – Gaston Leroux £8.99
Monsieur de Phocas – Jean Lorrain £8.99
The Woman and the Puppet (La femme et le pantin) – Pierre Louÿs £6.99
Portrait of an Englishman in his Chateau – Pieyre de Mandiargues £7.99
Abbé Jules – Octave Mirbeau £8.99

Le Calvaire – Octave Mirbeau £7.99
The Diary of a Chambermaid – Octave Mirbeau £7.99
Torture Garden – Octave Mirbeau £7.99
Smarra & Trilby – Charles Nodier £6.99
Tales from the Saragossa Manuscript – Jan Potocki £5.99
Monsieur Venus – Rachilde £6.99
The Marquise de Sade – Rachilde £8.99
Enigma – Rezvani £8.99
The Wandering Jew – Eugene Sue £10.99
Micromegas – Voltaire £4.95

Forthcoming titles include:

Sebastien Roch – Octave Mirbeau £9.99
The Man in Flames (L'homme encendie) – Serge Filippini £10.99
L'Eclat du sel – Sylvie Germain £8.99

Anthologies featuring French Literature in translation:

The Dedalus Book of French Horror: the 19c – ed T. Hale £9.99
The Dedalus Book of Decadence – ed Brian Stableford £7.99
The Second Dedalus Book of Decadence – ed Brian Stableford £8.99
The Dedalus Book of Surrealism – ed Michael Richardson £9.99
Myth of the World: Surrealism 2 – ed Michael Richardson £9.99
The Dedalus Book of Medieval Literature – ed Brian Murdoch £9.99
The Dedalus Book of Sexual Ambiguity – ed Emma Wilson £8.99
The Decadent Cookbook – Medlar Lucan & Durian Gray £8.99
The Decadent Gardener – Medlar Lucan & Durian Gray £9.99

Siempre me va V. diciendo
Que se muere V. por mí:
Muérase V. y lo veremos
Y después diré que sí.

(You're always saying
That you'd die for me:
So let's see you die,
And then I'll agree.)

CHAPTER ONE

HOW ONE WORD WRITTEN ON AN EGGSHELL SERVED AS TWO SUCCESSIVE NOTES

The Spanish Carnival does not end, as does ours, at 8 o'clock on the morning of Ash Wednesday. The sepulchral odour of the *memento quia pulvis es*, reminding us that we are but dust, hangs over the marvellous gaiety of Seville for four days only, and on the first Sunday in Lent the entire Carnival comes to life again.

This is the *Domingo de Piñatas*, Cooking-pot Sunday, the Great Festival. Everyone in the working-class district has changed their costume, and a brightly-coloured horde of screaming kids can be seen running through the streets, their small brown bodies decked out in red, blue, green, yellow or pink tatters of what were once mosquito nets, curtains or ladies' petticoats, and which float behind them in the sunshine. They group together on all sides in tumultuous battalions that wave a rag about on the end of a stick and conquer the alleys with loud cries, incognito under their velvet masks, which let the delight in their eyes escape through the two holes. *"Hey, you there! Who am I then?"* they shout, and the crowd of grown-ups makes way for these terrifying masked invaders.

Countless dark heads throng the windows and the enclosed balconies. All the young girls from miles around have come to Seville for the day, and they lean forward in the sunlight, their heads weighed down under an abundance of hair. Confetti falls like snow.

11

The girls' fans cast a pale blue shadow over their delicate powdered cheeks. Screams, shouts and laughter hum and shrill in the narrow streets. On this Carnival day, several thousand townspeople make more noise than the whole of Paris put together.

Nevertheless, on 23rd February 1896, *Piñatas* Sunday, André Stévenol viewed the approaching end of the Seville Carnival with a slight feeling of resentment, for this essentially amorous week had not provided him with any new love affair. And yet, after a few stays in Spain, he knew with what suddenness and what candour close ties are still often established or severed in this eternally primitive land, and so he was grieved that neither fortune nor opportunity should have favoured him.

The only exception had been when a young girl with whom he had engaged in a long battle of streamers between the street and the window had run downstairs, after beckoning to him, in order to hand him a small red bouquet, saying, in her Andalusian accent, *"Thank you very much, sir"*. But she had gone back up again so quickly and, besides, seen close up she had proved such a disappointment, that André had contented himself with putting the bouquet into his buttonhole and the woman out of his mind. And the day just seemed even emptier.

4 o'clock rang out from twenty bell towers. He left Las Sierpes, passed between la Giralda and the ancient Alcázar and, following the calle Rodrigo, came to las Delicias, a Champs-Elysées of shady

trees running alongside the immense Guadalquivir river, that was teeming with vessels.

It was there that the fashionable Carnival took place.

In Seville, the leisured classes are not always rich enough to be able to afford three square meals a day, but they would rather go hungry than deny themselves the external luxury which for them consists uniquely in the possession of a four-wheeled carriage and a pair of flawless horses. This small provincial town can boast fifteen hundred of these privately-owned conveyances, often old-fashioned in design, but rejuvenated by the beauty of the animals; moreover, they are occupied by countenances of such noble extraction that, given the fine picture they present one would never dream of poking fun at the surrounding frame.

André Stévenol managed with great difficulty to push his way through the crowd that lined both sides of the vast, dusty avenue. The cries of children plying their trade rose above everything else: *"Eggs! Eggs! Who wants eggs? Tuppence a dozen!"* It was the egg-fight.

In yellow wickerwork baskets hundreds of eggs were piled up. They had been emptied, then filled with confetti and sealed up again with a flimsy wrapper. The idea was to fling them with all one's might, like schoolchildren playing ball, at people's faces as they happened to go past in their slow-moving carriages. And the *caballeros* and the *señoras*, standing on their blue seats, and sheltering as best they could behind their small pleated fans, returned fire on the dense crowd.

Right at the outset André had filled his pockets with these harmless missiles, and he fought with spirit.

It was a genuine combat, for although the eggs never injured anyone, they could still give you a sharp blow before bursting into a cloud of coloured snow, and André found himself flinging his a little more vigorously than was really necessary. On one occasion, he even broke a fragile tortoiseshell fan in two. But then, fancy turning up to a free-for-all of this kind with a ballroom fan! And he carried on as if nothing had happened.

Carriages went by, some full of women, others bearing lovers, families, children or friends. André watched this happy multitude stream past, buzzing with laughter in the early spring sunshine. On several occasions his gaze came to rest on a pair of wonderful eyes, for the young girls of Seville, instead of lowering their eyelids, accept the tribute of such stares, which they hold for a long time.

As the game had already been going on for an hour, André felt that he could withdraw, and he was hesitantly turning his last egg around in his pocket when he suddenly saw the young woman whose fan he had broken reappear.

She was stunning.

Deprived of the screen that had for a while protected her delicate, laughing features, and exposed on all sides to the attacks that came from both the crowd and the neighbouring carriages, she had resigned herself to the inevitable battle and, standing up, with her hair dishevelled, panting and flushed

from the heat and from sheer high spirits, she was giving as good as she got!

She looked about twenty-two years old, but she must have been nearer eighteen. As to her being Andalusian, there could be no doubt about that. She possessed those wonderful looks that are born of the mixing of Arabs with Vandals – Semites with Germans – which quite exceptionally brings together, in one small European valley, all the contrasting elements of perfection of both races.

Every inch of her long, supple body was expressive. You felt that even if her face were veiled, you would still be able to guess her thoughts, and that she spoke with her torso just as she smiled with her legs. Only women who do not have to spend long Northern winters huddled around the fire possess this grace and this freedom. Her hair was really a deep reddish brown, but from a distance it shone almost black as it covered her nape with its thick conch-like form. Her cheeks, whose contours were extremely smooth, seemed to have been dusted with that delicate bloom which shades the complexion of Creoles. The thin edges of her eyelids were naturally dark.

André, pushed forward by the crowd right up to the carriage steps, gazed at her attentively for some time. He smiled, feeling quite overcome, and the rapid beating of his heart told him that this was one of those women who would play an important part in his life.

Without losing a moment, for the flow of carriages that had been brought to a temporary standstill

might start moving again at any second, he stepped back as best he could. Then he took the last of his eggs out of his pocket, wrote in pencil on the white shell the Spanish for *I love you* and, picking a moment when the stranger's eyes had fastened on his, he gently tossed the egg up to her, like a rose.

It landed in the young woman's hand.

The Spanish word for *to love* ("querer") is an amazing verb that says everything, for it also means *to wish, to desire* and even *to seek* and *to cherish*. By turns, and according to the inflection one gives to it, it can express the most imperious passion or the merest passing fancy. It can be either an order or an entreaty, a declaration or plain condescension. Sometimes it is just ironic.

The look with which André accompanied it simply signified: "I would love to love you".

As if she had somehow guessed that this eggshell bore a message, the young woman slipped it into a small leather bag that was hanging in the front part of her carriage. She was doubtless going to turn round, but the streaming procession swept her swiftly away towards the right and, with the arrival of other carriages, André lost her from view before he had a chance to force his way through the crowd in pursuit of her.

Moving away from the pavement, he was able to get clear, and run into a side-alley. But the multitude that filled the avenue hindered his progress, and by the time he had managed to climb up onto a

bench which gave him a commanding view of the battle, the young face he was seeking had disappeared.

Slowly and sorrowfully, he made his way back through the streets. As far as he was concerned, a cloud had suddenly been cast over the entire Carnival, and he was angry with himself about the wretched misfortune that had just cut short his adventure. Had he been more determined, he might perhaps have been able to find a way through between the carriage wheels and the front row of the crowd. But where could he hope to find that woman again now? Did she even live in Seville? If, as ill luck would have it, this was not the case, then where should he look for her – in Cordoba, in Jerez, or in Malaga? It was just impossible.

And, little by little, through some deplorable trick of the imagination, the mental picture he had of her increased in charm. Certain facial details, that in themselves would scarcely have been worthy of note, unless for curiosity's sake, became in his memory the principal reasons for his feeling of heartrending tenderness. Thus he had noticed that instead of letting the two locks of loose hair above her temples hang down straight, she gave them extra body by forming them into two round loops with curling tongs. It was not a very original style, and plenty of women in Seville went to the same trouble; but no doubt their type of hair was not so well-suited to the perfection of these ball-shaped ringlets, for André could not recall having seen any

17

which, even from a distance, could bear comparison with hers.

Furthermore, the corners of her lips were extremely mobile. Animated by a flame of varying intensity, both their shape and their expression were continually changing – now nearly invisible, now almost curling up; round or thin, pale or dark. Oh, one could find fault with all the rest, and maintain that her nose was not Greek, nor her chin Roman; but not to have blushed with pleasure at the sight of those two little corners of her mouth – why, that would have been quite unthinkable!

His thoughts had run on thus far when a rough cry of *"Look out there!"* made him take cover in an open doorway. A carriage went past in the narrow street at a jog trot.

And in this carriage there was a young woman who, on seeing André, threw him, ever so gently, as one throws a rose, an egg that she was holding in her hand.

By a stroke of good fortune, it rolled over as it fell and did not break, for André, utterly astounded by this fresh encounter, had made no attempt to catch it in mid-air. The carriage had already turned the street corner by the time he stooped down to pick the egg up.

The words for *I love you* could still be read on the smooth, round shell, and no others had been added; but a bold flourish, seemingly carved with the point of a brooch, completed the final letter, as if to reply with the same message.

IN WHICH THE READER LEARNS THE DIMINUTIVE FORMS OF THE SPANISH CHRISTIAN NAME "CONCEPCIÓN"

However, the carriage had turned the street corner, and now one could only faintly distinguish the sound of the horses' hooves as they rang out on the flagstones near the Giralda.

André chased after it, anxious not to let slip this second, and perhaps final, opportunity. He arrived just as the horses, which had slowed down to a walking pace, were disappearing into the shadow of a pink house that stood on the Plaza del Triunfo.

The large black iron gates opened and then closed again as a woman's silhouette swiftly passed between them.

It would no doubt have been more sensible to have prepared the ground beforehand, to have made enquiries, to have found out her name, and asked about her family and her social position, and the kind of life she led, before rushing headlong like this into the unknown, into an affair in which, as he knew nothing, he would have no control. Nevertheless, André could not bring himself to leave the square without having made at least an initial effort, and so once he had quickly run his hand over his hair and checked that his tie was properly done up, he resolutely rang the bell.

A young butler appeared behind the gate, which he did not open, and said:

"What can I do for you, sir?"

"Please have my card sent in to the *señora*."

"To which *señora*, sir?" the servant calmly replied, a slight note of suspicion entering his otherwise respectful voice.

"To the one who lives in this house, I should think."

"But what is her name?"

André, whose patience was already wearing thin, did not reply.

"Would you please be so kind, sir," continued the servant, "as to inform me into which *señora*'s presence I am to show you."

"But your mistress is expecting me, I tell you."

The butler bowed, raising his hands slightly as he did so, in a gesture intended to convey the impossibility of the request. Then he withdrew, without opening the gates, or even having taken the card.

In his anger André quite forgot his manners, and he rang a second and then a third time, as if he were at a tradesman's door. "A woman who responds so promptly to such a declaration," he said to himself, "can hardly be surprised at one's insistence in trying to gain admittance to her house. She was on her own in las Delicias, she must live alone here, and she's the only one who can hear the noise that I'm making at the moment." He was forgetting that the Spanish Carnival allows certain fleeting liberties that cannot possibly be continued into normal,

everyday life with any likelihood of receiving the same welcome.

The door remained shut and the house in silence, as if it were empty.

What should he do? For a while he walked up and down the square in front of the windows and the enclosed balconies, at which he was still hoping to see the longed-for face appear, and perhaps even some sort of sign . . . But it was all in vain, and he resigned himself to having to go back to his hotel.

However, before finally leaving this door, behind which lay so many mysteries, he espied not far off, seated in a shady corner, a man selling matches.

"Who lives in this house?" he asked him.

"I don't know," the man replied.

André placed a couple of pesetas in his hand, adding:

"Tell me anyway."

"I shouldn't really. The *señora* buys her matches from me, and if she knew I'd been talking about her, then tomorrow her servants would go and get them from someone else – from El Fulano, for example, who sells his boxes half-empty. At any rate, I won't say anything bad about her, *cabayero*, I won't speak ill of her! I'll just give you her name, since you want to know it. She's señora Doña Concepción Pérez, the wife of Don Manuel García."

"Doesn't her husband live in Seville, then?"

"He's in *Bolibie*."

"Where?"

"In *Bolibie*. It's somewhere in South America."

*

Without waiting to hear any more, André tossed another coin into the match-seller's lap and, merging into the crowd, he headed back towards his hotel.

All in all, he still felt rather undecided. Even with the husband's absence, about which he had just learnt, he was not convinced that luck was entirely on his side. The reticence of the match-seller, who seemed to know more than he was willing to reveal, suggested that she had already chosen a lover, and the servant's behaviour was hardly calculated to allay this underlying suspicion. Bearing in mind that scarcely a fortnight remained before the date fixed for his return to France, André wondered whether this would be long enough to enable him to find favour with a young lady whose personal life was doubtless already accounted for.

He was still wrestling with his uncertainty when, just as he was entering the hotel patio, the doorman stopped him, saying:

"I've a letter for you, sir."

There was no address on the envelope.

"Are you sure that this letter is for me?"

"It was handed to me only a moment ago, sir, to be given to Don André Stévenol."

André opened it without more ado.

It contained a blue card, on which was written the following brief message:

"Don André Stévenol is requested not to make so much noise, not to give his name, and not to ask for

24

mine again. If he goes for a walk along the Empalme road tomorrow afternoon, towards 3 o'clock, a carriage will go by and may, perhaps, pull up."

"How simple life is!" thought André.

And as he went up the stairs to the first floor, he was already picturing to himself the intimate encounters that lay ahead, and trying to recall the affectionate diminutives of the most charming of all Christian names:

"Concepción, Concha, Conchita, Chita."

CHAPTER THREE

HOW, AND FOR WHAT REASONS, ANDRÉ DID NOT GO TO CONCHA PÉREZ'S RENDEZVOUS

The following morning was a radiant one. When André awoke, light was streaming in through the four windows of the balcony, and on the white square outside all the sounds of town life – horses' hooves, hawkers' cries, bells belonging to mules or to convents – were mingling together in a general animated hum.

He could not recall having had such a joyous start to the day in a long while. He stretched out his arms and tensed them, feeling their strength. Then, as if in anticipation, he clasped them tight to his chest in an illusory embrace.

"How simple life is!" he said again, smiling to himself. "At the same time yesterday, I was alone, aimless and uninspired. All I had to do was go for a stroll, and now here I am, part of a couple! So why do we always expect to be spurned, scorned or even kept waiting? If we just ask, women give themselves. And why should it be otherwise?"

He got out of bed, put on his slippers, wrapped a long cotton loincloth around his waist, and rang for his bath to be prepared. While he was waiting, he pressed his forehead up against the windowpanes, and looked out at the sunlit square.

The houses were painted in those light colours, reminiscent of women's dresses, with which Seville

loves to decorate its walls. Some were cream-coloured, with pure white cornices; some were pink (but of such a delicate shade!); others were orange or sea-green; and others still pale violet. And nowhere were one's eyes offended by the hideous brown of the streets of Cadiz or Madrid, or dazzled by the glaring whiteness of Jerez.

On the square itself there were orange trees laden with fruit, flowing fountains, and young girls who were laughing as they held the borders of their shawls together in both hands, just like Arab women fastening their loose outer garments. And from all around – from the four corners of the square, the middle of the road, the depths of the narrow alleys – came the tinkling sound of the little bells worn by the mules.

André simply could not imagine how one could live anywhere else but Seville.

After he had finished washing and dressing, and had lingered over a small cup of thick Spanish chocolate, he set out once more, determined to go wherever his feet should happen to take him.

And, strangely enough, it so happened that they took him by the shortest route from the steps of his hotel to the Plaza del Triunfo; but, once there, André recalled the precautions he had been advised to observe and, either because he was afraid of displeasing his "mistress" by passing right in front of her house, or, on the contrary, because he did not wish to appear so tormented by the desire to see her that he

could wait no longer, he continued along the opposite pavement without so much as a sideways glance to the left.

From there, he made his way towards las Delicias.

The whole area was strewn with eggshells and bits of paper from the previous day's battle, which made the magnificent park vaguely resemble a kitchen scullery, and here and there the ground was completely hidden from view beneath what looked like crumbling, variegated dunes. Moreover the place was deserted, for Lent had begun again.

And yet, coming towards him along a path that led in from the countryside, André saw a figure that he recognised.

"Good morning, Don Mateo!" he said, holding out his hand. "I didn't expect to run into you at this early hour."

"What else is there to do, sir, when one is alone, idle and useless? I go for a walk in the morning, and again in the evening. During the day I read or go out gambling. That's the life I've chosen to lead, and it's a gloomy one."

"But your nights provide some consolation for such days, if I'm to believe local gossip."

"If they're still saying that about me, they're mistaken. You'll never see another woman at Don Mateo Díaz's, not from now to his dying day. But don't let's talk about me any more. How much longer are you staying here for?"

Don Mateo Díaz was a Spaniard, aged about forty, to whom André had been given a letter of introduction

during his first visit to Spain. His gestures and his manner of speech were both naturally rather declamatory and, like many of his fellow country-men, he was apt to take offence at the most innocent remarks. Not that this implied any conceit or stupid-ity on his part: the grandiloquence of the Spanish matches their cloaks, which are worn with large, elegant folds in them. Don Mateo was an educated man, and it was only his considerable personal fortune that had prevented him from leading an active life. He was principally known on account of his bedchamber, which had a reputation for hospi-tality. Consequently André was astonished to learn that he had already renounced the devil and all his wicked pomps and vanities. Nevertheless, the young man refrained from posing any more questions.

For a while they walked along by the Guadalquivir which Don Mateo, being a riverside landowner, and proud of his city, never tired of admiring.

"I'm sure you've heard," he would say, "about the foreign ambassador who joked that he preferred the Manzanares to all other rivers, because it could be navigated both in a carriage and on horseback. But behold the Guadalquivir, father of cities and plains! I've travelled widely during the last twenty years, and I've seen broader rivers in brighter climes – the Ganges, the Nile, the Atrato – but only here have I seen waters and currents of such majestic beauty. Its colour is incomparable. Doesn't that look just like spun gold, tapering down to the arches of the bridge? Sometimes the river swells like a pregnant woman,

and then the water becomes heavy with soil. It's all the wealth of Andalusia that passes through Seville's two wharves, on its way down towards the plains."

Then they talked politics. Don Mateo was a royalist, and he was outraged by the persistent attacks of the republican opposition at a time when all the country's forces ought to have been focused around the helpless but courageous queen, in order to help her preserve the supreme heritage of an imperishable past.

"What a decline!" he would say. "What woe! To think that we were once the masters of Europe! We gloried in the might of Charles the Fifth, we doubled the scope of the world's activities by discovering a new one, we possessed the empire on which the sun never set and, better still, were the first to defeat your Napoleon – and all this only to perish beneath the cudgels of a handful of mulatto bandits! What a fate for Spain!"

It would never have done to have told him that those same bandits were Washington's and Bolívar's brothers. As far as he was concerned, they were shameful brigands who didn't even deserve to die by the garrotte.

He calmed down, and then continued:

"I love my country. I love its mountains and its plains. I love the people's language and dress, and the feelings they express. Our race is naturally endowed with superior qualities. It constitutes an aristocracy in its own right, standing aloof from the rest of Europe, interested only in itself, and remaining shut

away on its estates as if within a walled garden. That no doubt explains why it's in decline – and to the benefit of the Northern nations, in accordance with that contemporary law which seems to impel the mediocre everywhere to attack all that is finest. In Spain, you know, the descendants of families that have no trace of Moorish blood in their veins are considered members of the nobility. We're unwilling to admit that, for seven hundred years, Islam took root in Spanish soil. Personally, however, I've always thought that to disown such ancestors was to display great ingratitude. To whom, if not to the Arabs, do we owe those outstanding qualities that have enabled us to stamp the pages of history with the mighty portrait of our past achievements? They've bequeathed to us their contempt for money, falsehood and death, as well as their inexpressible pride. Our exceptionally upright attitude when confronted with all that is base comes from them, as does a certain indefinable indolence with regard to manual work. In truth, we are their children, and it's not without reason that we continue, to this day, to perform their Oriental dances to the sound of their 'fierce ballads'."

The sun rose higher in the broad expanse of clear, blue sky. The old trees that stood like masts in the park were still brown, although in places the green of laurels and supple palms could be seen peeping through. Sudden blasts of hot air cast their spell over this winter's morning, in a land where winter never lingers.

*

"You'll come and have lunch with me, I hope," said Don Mateo. "My estate lies over that way, near the Empalme road. We can be there in half an hour and, if you have no objection, I'll detain you till evening, in order to show you my stud farm, where I've some new animals."

"You'll think me terribly rude," apologised André. "I accept the invitation to lunch, but not the excursion. I've a rendezvous later this afternoon that I really must keep."

"With a woman? Have no fear, I won't ask questions. Go right ahead. In fact, I'm grateful to you for spending with me such time as remains before the appointed hour. When I was your age, such days were filled with mystery and I couldn't bear to see anyone at all. I'd have my meals brought to me in my room, and the woman I was waiting for would be the first person I had spoken to since waking up that morning."

He fell silent for a moment, and then, as if by way of advice, he added:

"Ah! Beware of women, sir! I'm not suggesting that you shun them altogether, for I've worn my life out in their company, and if I had to begin it all over again, the hours so spent would be among those I'd wish to relive. All the same – be careful, be very careful where they're concerned!"

Then, as if he had hit upon an expression that neatly summed up his thoughts on the matter, Don Mateo slowly added:

*

"There are two kinds of women that should be avoided at all costs: firstly, those that do not love you; and secondly, those that do. Between these two extremes there are thousands of delightful women — only we don't know how to appreciate them."

Lunch would have been a rather dull affair had Don Mateo, who was in good form, not livened it up with a long monologue that helped make up for the conversation that was otherwise lacking; for André, engrossed in his own private thoughts, was only half-listening to what was being said to him. As the moment of his rendezvous drew nearer, so his heart-beat quickened, and the palpitation that he had first felt stirring inside him the day before grew ever more insistent. It was like a deafening summons from within himself, an imperious command that banished from his thoughts everything but the woman he was waiting for. He would have given anything for the little hand of the Empire clock on which his gaze was fixed to have been moved forward by fifty minutes. But time seems to stand still when one keeps looking at the clock, and now it slipped by no faster than the water in an eternally stagnant pond.

At length, obliged to remain, and yet unable to keep quiet a moment longer, he betrayed something of his relative youth by addressing his host in the following unexpected terms:

"Don Mateo, you've always given me excellent advice. Would you mind if I told you a secret, and then asked for your opinion?"

"I'm entirely at your disposal," said Don Mateo, with typical Spanish courtesy, as he rose from the table in order to go through into the smoking room.

"Er ... well now ..." André stammered, "it concerns ... Really, I wouldn't broach the subject with anyone else, but ... Do you happen to know anyone in Seville called Doña Concepción García?"

Mateo gave a start.

"Concepción García! Concepción García! But which one? Explain yourself! There are thousands of Concepción García's in Spain! It's as common a name here as Jeanne Duval or Marie Lambert in your own country. For God's sake, tell me her maiden name. Tell me now, is it P ... Pérez? Is it Pérez? Concha Pérez? Well say something then!"

André was completely taken aback by this sudden display of emotion, and he had a fleeting premonition that it would be better not to tell the truth; but before he could stop himself he blurted out, rather sharply:

"Yes."

Then, emphasising each detail as if probing at a wound, Mateo continued:

"Concepción Pérez de García, 22 Plaza del Triunfo, eighteen years old, hair nearly black, and lips ... lips ..."

"Yes," said André.

"Ah! You've done the right thing in asking me about her. You've done the right thing, sir. If I can stop you from crossing that woman's threshold,

that'll be a good deed on my part, and a rare stroke of luck for you."

"But who is she?"

"What! You mean you don't know her?"

"I met her for the first time yesterday, and I haven't even heard her speak yet."

"In that case, it's not too late!"

"She's a harlot?"

"No, no. All things considered, she's actually rather respectable. She hasn't had more than four or five lovers, and in this day and age, that's chaste indeed."

"And . . ."

"Furthermore, she's remarkably intelligent. Remarkably so. Take my word for it. I consider her to be without equal, both for her shrewd mind and for her intimate knowledge of life. I'll give the woman her due. She displays the same irresistible eloquence when she dances as when she speaks, when she speaks as when she sings. That she has a pretty face – well, I expect you know that already; and if you were to see the rest of her, you'd say that even her lips . . . But that's enough of all that. Have I left anything out?"

Irritated, André did not reply.

Then Don Mateo seized hold of the sleeves of his jacket and, accentuating each and every word with a tug, he added:

"And she's the WORST of women, sir. Do you hear me, sir? She's the WORST woman in the whole wide world. My only consolation now is the heart-

felt hope that, the day she dies, God will not forgive her."

André stood up.

"Nevertheless, Don Mateo," he said, "as yet I'm not entitled to speak of this woman as you do, and I've no right not to go to the rendezvous that she's given me. I need hardly remind you that what I've told you is a secret, and I regret now having to interrupt yours by an early departure."

And he held out his hand.

Mateo, however, went and stood in front of the door.

"Listen to me, I beseech you. Just listen to me. Only a moment ago you were saying that I could always be relied upon to give excellent advice. I don't agree with you there; nor do I require any such praise in order to speak to you in this way. And leaving aside also the affection I have for you, and which would, moreover, be quite enough in itself to account for my insistence . . ."

"Well, what is it?"

"I'm going to speak to you man to man, just as someone might stop a passer-by in the street to warn him of some serious danger; and so let me cry out to you: Stop right there! Turn back, and forget all about whoever you've seen, whoever's spoken to you, whoever's written to you! If you already enjoy peace, calm nights, a carefree life, and everything else that goes by the name of happiness – keep away from Concha Pérez! Unless you want to see this very day divide your past from your future in two halves of

joy and anguish – keep away from Concha Pérez! If you haven't yet experienced to the utmost degree the folly that she can engender and maintain in a man's heart – keep away from that woman, flee her as you would death itself, and let me save you from her! In short, take pity on yourself!"

"Do you love her then, Don Mateo?"

The Spaniard put his hand to his forehead and murmured:

"Oh! that's over and done with now. I no longer either love her or hate her. It's all in the past. Everything fades away in the end . . ."

"In that case, perhaps you won't take it personally if I refrain from following your advice? I'd willingly make such a sacrifice for your sake, but there's no need for me to do so for my own . . . What do you say?"

Mateo looked at André; then suddenly changing the expression on his face, he facetiously replied:

"My dear sir, one should never go to the first rendezvous that a woman gives to one."

"And why's that?"

"Because she won't show up."

This witticism brought back a particular memory for André, and he could not help smiling.

"That's sometimes true," he admitted.

"Frequently. And if by any chance she were waiting for you at this very moment, you can be quite certain that your absence would only ensure her inclination for you."

*

40

André thought this over for a moment, and then smiled again.

"Which means . . .?"

" . . . Which means that leaving personal considerations aside, and even supposing that the woman you're interested in were called Lola Vásquez or Rosario Lucena, I'd advise you to return to the armchair in which you were seated a moment ago, and not to leave it again without very good reason. We're going to smoke a cigar or two whilst enjoying an iced fruit cordial. It's a combination rarely found in the restaurants of Paris, but it's common enough throughout Latin America. In a moment you must tell me whether you're enjoying to the full the blend of Havana smoke and cool sugar."

A short silence ensued. They had both sat down on either side of a small table, on top of which were cigars and circular ashtrays.

"Well now, and what shall we talk about?" enquired Don Mateo.

André just gestured, as if to say: You know perfectly well.

"I'll begin then," continued Mateo, lowering his voice; and the assumed cheerfulness he had momentarily displayed vanished as a lasting cloud of gloom settled over his features.

APPARITION OF A LITTLE MOORISH GIRL IN A POLAR LANDSCAPE

Three years ago, sir, I didn't have these grey hairs that you can see now. I was thirty-seven years old, but I thought I was still twenty-two. Never, at any moment in my life, had I been aware that my youth was slipping away, nor had anyone yet made me understand that it was coming to an end.

You've been told that I was a womaniser. It's not true. I've always had too great a respect for love to ever wish to frequent the back rooms of certain establishments, and I've hardly ever possessed a woman with whom I wasn't passionately in love. If I were to run through their names for you, you'd be surprised how few of them there are. Only recently, while doing this simple sum in my head, it struck me that I'd never had a blonde mistress. I'll never have known those pale objects of desire.

What is true, however, is that for me love has never been simply a distraction or a pleasure – a mere pastime, as it is for some. It's been the very essence of my life. If I were to erase from my memory all the thoughts and deeds that have revolved around women, there'd be nothing left, only emptiness.

Now that has been said, I can tell you what I know about Concha Pérez.

*

Three years ago – three and a half, to be exact – I was returning from France in the express train that crosses the bridge at Bidasoa towards noon. It was 26th December, and bitterly cold. The snow, already extremely heavy over Biarritz and San Sebastián, had made the route through Guizpúzcoa practically impassable. The train had to wait for two hours at Zumárraga whilst workmen hurriedly cleared the track; then we set off once more, only to stop again, this time in the middle of the mountains, and it took three hours to repair the damage caused by an avalanche. All night long, it was the same thing. The carriage windows, thickly coated in snow, deadened the noise of our journey, and the danger lent a certain grandeur to the silence through which we were travelling.

Next morning we drew up outside Avila. The train was running eight hours late, and we hadn't eaten anything for a whole day. When I asked a railway employee whether we could get out, he shouted back:

"Four day's halt. The trains can't get through."

Do you know Avila? It's the place to send anyone who thinks that the old Spain is dead. I had my bags carried to an inn, such as Don Quixote might have stayed at. There were fringed leather trousers stretched out over the fountains and in the evening, when shouting in the streets outside informed us that the train was suddenly leaving again, the stagecoach drawn by black mules that swept us off at a gallop through the snow, all but overturning a dozen times, was undoubtedly the very same one that long ago

used to convey King Philip the Fifth's subjects from
Burgos to the Escorial.

What I've just described to you in the space of a few
minutes, sir, actually lasted forty hours.

And so when, towards 8 o'clock at night, in the
middle of winter, and deprived of my dinner for the
second day running, I resumed my corner-seat in the
rear of the train, it's hardly surprising that I found
myself suddenly overcome by the most terrible feel-
ing of irritation. I simply didn't feel up to spending a
third night in the same carriage as the four sleeping
Englishmen who'd been with me since Paris. I left my
bag in the luggage rack and, taking my blanket with
me, I settled down as best I could in a third class
compartment, which was full of Spanish women.

In fact, I should really have said four compart-
ments, not one, for the partitions between each sec-
tion weren't much higher than the seats themselves.
In them there were a number of working class
women, a few sailors, a couple of nuns, three stu-
dents, a gypsy and a Civil Guardsman. It was a
mixed crowd, as you can see, and they all spoke at
once, in extremely shrill voices. I'd hardly been sit-
ting there for more than a quarter of an hour, and
yet I already knew the life story of everyone around
me. Some people make fun of those who confide in
others in this way, but personally I can never observe
without being moved to pity this need that simple
folk have to cry out their sorrows in the wilderness.

All of a sudden the train stopped. We were cross-
ing the Sierra de Guadarrama, at an altitude of

1400m., and a fresh avalanche had just barred our way forward. The train tried to back up, but another one was blocking our retreat. And the snow kept on falling, gradually burying the carriages.

It sounds more like an account of Norway that I'm giving you doesn't it? If we'd been in a Protestant country, everyone would have gone down on their knees, commending their soul to God; but, except when it thunders, we Spanish don't fear any sudden retribution from on high. On learning that the train was quite definitely trapped, everyone turned to the gypsy, and asked her to dance.

And dance she did. She was about thirty years old and, like most women of her race, extremely ugly; but from her waist down to her calves, she seemed to be on fire. In no time at all the snow, the cold, and the darkness outside were forgotten. The passengers in the other compartments were kneeling on the wooden benches and, with their chins resting on the partitions, they too were watching the gypsy. Those nearest to her struck the palms of their hands in time to the changing rhythms of her *flamenco* dance.

It was then that I noticed, in the corner opposite me, a little girl who was singing.

She was wearing a pink petticoat, which told me straightaway that she was from Andalusia, for Castillians prefer darker colours, such as the black worn by the French, or the brown favoured by the Germans. Her shoulders and nascent bosom were hidden beneath a cream-coloured shawl, and to protect herself against the cold, she'd wrapped around her head

a white scarf, whose ends hung down behind her in two long points.

As everyone else in the carriage already knew, she was a pupil at the Convent of San José in Avila who was on her way to Madrid to meet her mother. I also learnt that she didn't have a fiancé, and that her name was Concha Pérez.

Her voice was unusually piercing. She sang without moving, lying almost stretched out with her hands under her shawl and her eyes closed; but I don't think that it was the nuns who'd taught her what she was singing. She chose well from amongst those four line folk songs into which the common people put all their passion. I can still hear the way her voice seemed to caress you when she sang:

> *"Tell me, my girl, if you love me;*
> *Open up to me now, and let's see . . ."*

or:

> *"Thy couch is of jasmine,*
> *With white roses for sheets,*
> *Thy pillows are lilies –*
> *And now, sweet rose, sleep."*

Those are just some of the milder ones.

Suddenly, however, as if she'd sensed the absurdity of addressing such hyperboles to that savage creature, the style of her repertoire changed, and from then on she only accompanied the dancing with ironic songs such as this one, which I can still remember:

"Little girl with twenty lovers
(And with me that's twenty-one),
If they're anything like I am,
You'll end up all alone."

At first the gypsy didn't know whether to laugh or
get angry. The other passengers, who were all laugh-
ing, had been won over by the young singer, and it
was quite obvious that this particular "daughter of
Egypt" didn't count among her accomplishments
that readiness of wit which, in our modern societies,
is replacing a readiness with one's fists as the best
way to settle an argument.

She remained silent, gritting her teeth. Meanwhile
the little girl, quite reassured now as to the outcome
of her skirmish, became more impudent and high-
spirited than ever.

She was interrupted by a furious outburst from
the gypsy, who was raising her two clenched hands in
the air:

"I'll scratch your eyes out! I'll scratch your . . ."

"I'd better watch out then!" replied Concha, as
coolly as you please, without even raising an eyelid.
Then, amidst a torrent of abuse, she added in the
same calm voice, and just as if she had a bull in front
of her:

"Guards! Fetch me a couple of assistants!"

Everyone in the carriage was delighted. *¡Olé!* went
the men, whilst the women all looked at her with
good-natured affection.

Only once did she become flustered, and that
was in response to an insult that obviously touched

a nerve: the gypsy called her "a mere chit of a girl".

"I'm a woman," she cried, striking her tiny budding breasts.

And, with genuine tears of rage, the two combatants flung themselves at each other.

I intervened. I've never been able to watch women fighting with the same detachment that the common herd usually displays in front of such a spectacle. Women fight badly and dangerously. They're not familiar with the punch that can knock an opponent down; they only know how to scratch with their nails, which disfigures, or stab with a needle, which blinds. They frighten me.

I separated them, then, and it wasn't easy. None but a fool would come between two warring women! I did my best, however; after which, stamping their feet on the ground with suppressed fury, they sank back into their respective corners.

When everything had quietened down, a great big lanky fellow, wearing the uniform of a Civil Guardsman, suddenly appeared from an adjoining compartment. With his long, booted legs he stepped over the wooden partition that also forms the back of the seats, ran his eyes protectively over the battlefield, where there was nothing more to be done, and, unerringly going for the weakest person present, as the police invariably do, he gave poor little Concha a stupid, brutal slap in the face.

Without deigning to explain this summary verdict, he made the child move into another compartment,

then returned to his own with another great stride of his ridiculous boots, and solemnly folded his hands over his sword, with all the satisfaction of one who has just restored law and order.

The train had started up again by now. The scenery as we went past Santa María de las Nieves was incredible. An immense bowl-shaped hollow, almost entirely coated in whiteness, and bounded on the horizon by a pale mountain range, lay stretched out beneath a thousand-foot precipice. The very soul of this snow-covered sierra was clearly the brilliant, icy moon, and nowhere have I seen it more divine than there, on that winter's night. The sky was pitch black; the moon alone shone, along with the snow. At times, I had the impression that I was in a silent, fantastical train, on a voyage of polar discovery.

I was the only person to see this mirage. My fellow-passengers were all sound asleep. Have you ever noticed, my dear friend, how people never look at the things that are really worth seeing? Last year, for instance, as I was crossing Triana Bridge, I stopped to admire the most beautiful sunset of the year. Nothing can give you any idea of the splendour of Seville at such a moment. Well, then I looked at the passers-by. They were all going about their business, or chatting away as they strolled about, unable to escape their boredom; but not one of them turned round. That magnificent evening spectacle – no-one saw it.

As I gazed at the snow-filled, moonlit night, my eyes already growing tired of the dazzling whiteness, the image of the little girl who'd been singing flashed

through my mind, and this juxtaposition of the young Moorish girl and the Scandinavian landscape made me smile. It was something droll and illogical, like a tangerine on an ice floe, or a banana at the feet of a polar bear.

Where was she? I leant over the top of the partition and I saw that she was right by me, so close that I could almost touch her.

She'd gone to sleep with her mouth open and her arms folded beneath her shawl, and her head had slipped down so that it was resting on the arm of the nun beside her. I was quite willing to believe that she was a woman, as she'd told us so herself; but she slept, sir, like a six-month-old child. Her face was almost entirely muffled up in her tasselled headscarf, which hugged the rounded outline of her cheeks. A black ringlet of hair, a closed eyelid above long lashes, a small nose that caught the light and a pair of lips half-hidden in shadow – that's all that I could see of it, and yet I lingered till dawn over that singular mouth of hers, at once so childlike and so sensual that at times I wasn't sure whether the movements it made as she dreamt sought the wet nurse's nipple or a lover's lips.

Day broke as we were going past the Escorial. As far as the eye could see the wonders of the sierra had given way to the dull, dry winter of the suburbs. Shortly afterwards, we drew into the station and, as I was getting my case down, I heard a little voice outside crying:

"Look! Look!"

She was already out on the platform, pointing at

the mounds of snow which, from one end of the train to the other, covered the carriage roofs, stuck to the windows, and capped the buffers, the springs and the ironwork; and the pitiful appearance of our train when compared with the perfectly spotless ones that were waiting to leave the city was making her roar with laughter.

I helped her gather her bundles together, and I wanted to get someone to carry them for her, but she refused. There were six of them in all, and she swiftly got hold of their handles as well as she could, slipping one over her shoulder, dangling a second from her elbow, and taking the other four in her hands. Then off she ran.

And I lost sight of her.

You can see just how vague and insignificant this first encounter was, sir. It's no opening to a novel: more space is devoted to the setting than to the heroine, and I could have left her out altogether. But what could be more unpredictable than a love affair in real life? And that's truly how this one began.

Even today I'd swear that, if someone had asked me that same morning what had been the high point of the night for me, what memory I'd have later of those particular forty hours out of so many thousands of others, I'd have talked about the scenery, and not about Concha Pérez.

She'd kept me amused for twenty minutes or so. Her little image cropped up in my thoughts once or twice more, but then, having other business to attend to elsewhere, I moved on and soon forgot all about her.

CHAPTER FIVE

IN WHICH THE SAME PERSON REAPPEARS IN A MORE FAMILIAR SETTING

The following summer, I suddenly met her again.

I'd been back in Seville for quite some time, long enough to have picked up once more with an old flame, and then to have broken it off again.

But I'm not going to tell you about that. You're not here to listen to my life story; besides, I take little pleasure in confiding memories of a private nature. But for the strange coincidence that brings us together over a woman, I'd never have revealed this fragment of my past to you. Let's hope that even between the two of us this disclosure will remain an exception.

In August, for the first time in years, I found myself all alone in a house that had always been filled with a woman's presence. The second place-setting at the dinner table removed, no dresses in the wardrobes, an empty bed, silence everywhere ... If you've ever been a lover, you'll know what I mean and how horrible it is.

To escape the anguish of this loss, which was worse than any bereavement, I stayed out from dawn till dusk, wandering around aimlessly, on horseback or on foot, with a shotgun, or a walking stick, or else a book; sometimes I even slept at an inn so as not to have to go back home. One afternoon, for want of

anything better to do, I went into the tobacco factory in Seville – the Fábrica.

It was a sweltering hot summer's day. I'd lunched at the Hotel de París, and afterwards, while getting from Las Sierpes to the calle San Fernando, "at the time of day that sees only dogs and Frenchmen in the streets", I thought that the sun would finish me off.

I went in, then, and I went in alone, which is a special favour for, as you know, visitors are usually shown around this immense harem of four thousand eight hundred women (who are as free in their dress as in their speech) by a female supervisor.

That particular day was scorching, as I've said, and the women showed no hesitation in taking advantage of the tolerant attitude that allows them to undress themselves as they please in the unbearable atmosphere in which they have to live from June to September. Such a regulation is only humane, for the temperature in these long rooms is infernal, and it's only fair to grant the poor girls the same rights as ship's stokers. All the same, the end result is far from uninteresting.

The most fully-clothed – and these were the prudes – had nothing but a chemise about their body; but nearly everyone worked stripped to the waist, in a plain linen petticoat, loosened at the belt and sometimes pushed halfway back up the thighs. It made for a motley spectacle, depicting woman at every stage of her existence: there were the children, the elderly, the young and the not so young – obese, fat,

thin or emaciated. Some were pregnant. Others were breast-feeding their little ones. Others still weren't even nubile. You could find all sorts in this naked throng – except, no doubt, virgins. Some of the girls were even rather pretty.

I passed along the compact rows, looking left and right, sometimes solicited for alms and sometimes rudely greeted with the most cynical jokes, for the entry of a lone man into this colossal harem arouses a good deal of excitement. Believe you me, they don't mince their words once they've lowered their chemises, and they accompany what they're saying with certain gestures whose indecency, or rather simplicity, is somewhat disconcerting, even for a man of my age. These girls are every bit as shameless as respectable women!

I didn't reply to all of them. After all, who can hope to have the last word with a female cigar maker? But I watched them carefully, and as their nakedness accorded ill with the impression I got of an arduous occupation, I imagined that all these busy hands were hastily manufacturing for themselves numerous little lovers made from tobacco leaves. Moreover, they did all that was necessary to suggest the idea to me.

The contrast between the shabbiness of their linen and the extreme attention they lavish on their abundant hair is striking. They style it with a small pair of curling tongs, just as if they were off to a ball, and they powder themselves right up to the tips of

their breasts, and even over the holy medals they wear around their necks. There's not one of them who doesn't have forty hairpins and a red flower in her chignon; not one who doesn't have a small mirror and a white powder-puff at the bottom of her kerchief. They might be mistaken for actresses dressed up as beggars.

I considered them one by one, and it seemed to me that even the quietest let themselves be examined with some show of vanity. I also noticed that at my approach a few of the young ones, as if quite by chance, assumed more relaxed poses. I gave a few small coins, or *perras*, to those with children; to others the little bunches of carnations with which I'd filled my pockets, and which they immediately hung at their breasts from the small chains of their crosses. There were, to be sure, a few rather pitiful anatomies in this heterogeneous herd, but they were all interesting, and I stopped more than once in front of an admirable female body, such as one only really finds in Spain: a warm, fleshy bosom, velvety like a fruit and amply clad in the sleek skin, uniformly dark in colour, against which the curly astrakhan under the arms and the almost black rings of the breasts stand out strongly.

I saw fifteen that were beautiful. That's a lot, out of five thousand women.

Half-deafened, and a little weary, I was just going to leave the third room when, amidst all the shouting

and the lively conversation, I heard a small, crafty voice close by saying:

"*Caballero*, if you give me a *perra* as well, I'll sing a little song for you."

I recognised the speaker: it was Concha! I was quite astounded. I can picture her even now: she had on a long chemise which was a little worn, but which fitted her well around the shoulders and wasn't too low-cut. She was looking at me as she straightened a cluster of pomegranate flowers that she had in the first tress of her black pigtail.

"How did you get here?"

"Heaven knows. I don't remember any more."

"But what about your convent in Avila?"

"Girls that go back there through the door leave by the window."

"And that's how you left?"

"I'm a respectable girl, *caballero*. I didn't go back at all, for fear of committing a sin. Give me five *perras*, then, and I'll sing you a *flamenco* song while the supervisor's at the other end of the room."

You can just imagine how the other girls nearby were staring at us during this little dialogue. I was doubt-less rather discomfited by this myself, but Concha was quite unperturbed.

"So, who are you living with in Seville, then?" I went on.

"With mama."

I shuddered. For a young girl a lover is at least

some sort of a safeguard, whereas a mother – spells ruin!

"Mama and me, we keep ourselves busy. She goes to church, and I come here. It's the age difference."

"Do you come here every day?"

"More or less."

"Only 'more or less'?"

"Yes. When it's not raining, when I'm not feeling sleepy, when I get bored of going out for walks. You can come and go as you please here – ask the others. But you must be here at midday, or else you won't be let in."

"No later than that?"

"Don't joke. Midday – Heaven's above! As if that wasn't early enough! I know some who can't manage to get up in time two days running, and so they find the gate shut. And for what we earn, you know, we'd be better off staying at home."

"How much do you earn?"

"Seventy-five *céntimos* for a thousand cigars or for a thousand packets of cigarettes. As I do a good job, I get a peseta; but it's not exactly a fortune . . . Give me a peseta too, *caballero*, and I'll sing you a lively song that you haven't heard before."

I tossed a coin worth a napoleon into her box and, giving her ear a tweak, I left.

There comes, sir, during the youth of people who are happy, a precise moment when their luck turns, when the slope that was rising falls again, when the winter

months set in. That was mine, right then. That gold
coin thrown down in front of that girl was the fatal
dice in my game. I date from then my disgrace, moral
decline, and present way of life, as well as the
changes you can see here upon my brow. You'll
soon find out why. It's really a very simple story,
almost banal in fact, save in one particular. But it
has destroyed me.

I'd gone outside and was slowly walking down the
hot, sunny street when I heard the sound of little
footsteps running along behind me. I turned round:
she'd caught up with me.

"Thank you, sir," she said.

I noticed that her voice had changed. I hadn't
realised the effect that my little offering must
have had upon her; but now I saw that it had been
considerable. A napoleon is worth twenty-four
pesetas – the price of a bouquet. For a girl employed
making cigars that represents a month's work.
Furthermore, it was a gold coin, and gold is rarely
seen in Spain, except in the moneychanger's shop-
window.

Without meaning to, I'd conjured up for her all the
excitement of wealth.

Naturally, therefore, she lost no time in leaving the
cigarette packets she'd been cramming since morning
where they were. She put her petticoat, stockings
and yellow shawl back on, picked up her fan and,
after hastily powdering her face, she rejoined me as
fast as she could.

*

"Come along," she continued, "you're my friend. Thanks to you I'm on holiday now, so you can walk me back home to mother's."

"Where does she live, your mother?"

"Calle Manteros. It's not far. You've been very nice to me, but you weren't interested in my song, and that was wrong of you. So now, as a punishment, you're going to recite one for me."

"Oh no I'm not."

"Yes you are. I'll whisper it to you."

She leaned forward towards my ear.

"This is how it goes:

> *'Is there anyone listening? – No.*
> *– Do you want me to tell you? – Tell.*
> *– Have you got a lover then? – No.*
> *– Do you want me to be him? – Yes.'*

But it's only a song, you know, and those aren't my replies."

"Is that really true?"

"Oh, absolutely!"

"And why's that?"

"Guess."

"Because you don't like me?"

"I do though. I find you charming."

"But you already have a sweetheart?"

"No, I haven't."

"It's because of your piety then?"

"I'm very pious, but I haven't made any vows, *caballero*."

64

"And I doubt that it's out of indifference."

"No, sir."

"There are too many questions that I can't ask you, my dear child. If you have a reason, then tell me."

"Ah, I knew you wouldn't be able to guess! It was too difficult."

"Well, what is it then?"

"I'm still a virgin."

CHAPTER SIX

IN WHICH CONCHITA MAKES HERSELF KNOWN, HOLDS HERSELF BACK, AND DISAPPEARS

She said these words with such aplomb that I stopped short, feeling quite disconcerted, and rather embarrassed for her.

What was going on in the pretty little head of this provocative and rebellious child? What was the meaning of her confident behaviour, her open and perhaps honest expression, her sensual lips which proclaimed themselves intransigent as if deliberately to tempt one to take liberties with them?

I didn't know what to think, but I understood perfectly well that she greatly attracted me, that I was delighted to have found her again, and that I was now doubtless going to seek out every possible opportunity for watching her as she went about her life.

We arrived at the front door of her house, where a fruit-seller was unpacking her baskets.

"Buy me some tangerines," she said. "I'll offer them to you inside."

We went upstairs. I found the house disquieting. Nailed to the first door was a card with a woman's name on it, but not her profession. On the floor above there was a florist, and next door to her an apartment with closed shutters, from behind which came the sound of laughter. I was beginning to wonder whether this little girl wasn't simply leading me to

69

the most banal of rendezvous. But then again, the surroundings didn't prove anything: impoverished cigar makers don't have much choice when it comes to lodgings, and anyway I don't like to judge people simply according to the name of the street they live on.

She stopped on the landing of the top floor, along which ran a wooden bannister, and rapped three times on a brown door, which only opened with some difficulty.

"Let us in, mama," the child said. "I've brought a friend home with me."

Her mother – a dark-skinned woman, who still retained some traces of an otherwise faded beauty – looked me up and down distrustfully. But from the way in which her daughter pushed open the door and invited me to come right in, it immediately struck me that only one person was mistress in this hovel, and that the queen mother had abdicated the regency.

"Look, mama: a dozen tangerines . . . and look again: a gold coin!"

"Heaven's above!" exclaimed the old woman, clasping her hands together. "And how did you earn all that?"

I quickly explained to her about our double encounter, first in the railway carriage and again in the Fábrica, and then I tried to get her to talk about herself.

Which she did – endlessly.

She was, or at least claimed to be, the widow of an engineer who'd died at Huelva. Having returned to

Seville without a pension or any other means of support, she'd run through her husband's savings in four years, despite leading a frugal lifestyle. In short, whether true or not, it was a story that I'd heard a dozen times before, and that always ends with a cry for help.

"What can I do? I don't have a trade; I only know how to take care of the house and pray to the Holy Mother of God. I was offered a job as a concierge, but I'm too proud to work as a servant. I spend my days at the church. I prefer to kiss the flagstones in the choir than sweep those by someone else's front door, and I'm counting on the Good Lord to provide for me before it's too late. Two women on their own are so vulnerable! Ah! There are no lack of temptations for those so inclined, *caballero*! We'd be rich, my daughter and I, if we hadn't kept to the straight and narrow. We'd have slippers and necklaces! But sin has never spent the night under our roof. We're honest souls, we are, more upright than St. John's finger pointing to Heaven, and we put our trust in God, who always knows and looks after His own."

During this speech Conchita had been standing in front of a mirror that was nailed to the wall, working away on her swarthy little face with a couple of fingers and some powder, like an artist with his crayons. When she'd finished she turned round, and it seemed to me that her mouth was quite transfigured by the radiant smile of satisfaction that now lit up her features.

*

"Ah!" her mother went on, "How I worry when I see her setting off for the Fábrica in the morning! What a bad example they set her there! What nasty words they teach her! Those girls don't know the meaning of shame, *caballero*. You never know where they've just come from when they arrive there in the morning, and if my daughter had listened to them, she'd have run off and left me long ago."

"Why do you make her work there, then?"

"It'd be just the same elsewhere. You know how it is, sir: when two girls are working together for twelve hours on end, they spend eleven and three-quarter hours talking about what they oughtn't, and the rest of the time they're silent."

"If they only talk, there's not much harm in that."

"Mention food, and mouths water. Bah! Young girls are led astray by women's advice, not men's looks. I wouldn't trust the best of 'em an inch. She that carries a rosary in her hand, carries the devil in her skirt. Neither old nor young — no girlfriends: that's how I'd like it to be for my daughter. And *there* she has five thousand of them."

"In that case," I interrupted, "let her never return there again."

And I took two banknotes from my pocket and placed them on the table.

Exclamations . . . Clasped hands . . . Tears . . . — I'll spare you the details, which you can easily guess. But once their cries had died down, the mother, shaking her head, ruefully declared that her child would nevertheless certainly have to go back to work again, for the amounts owing to the landlord, the grocer, the

chemist and the second-hand clothes dealer were long overdue. In short, I doubled my gift, and immediately took my leave, modesty and self-interest both prompting me to keep quiet about my feelings that day.

*

* *

I won't deny that next morning, when I knocked at their door, it was barely 10 o'clock.

"Mama's out," Concha told me. "She's gone shopping. But come on in, my friend."

She looked at me, and then began to laugh.

"Well now, I'm very well-behaved in front of mama, don't you think?"

"Indeed you are."

"But please don't imagine it's because I've been taught good manners or anything like that. Fortunately for me, I've brought myself up all alone – for my poor mother would've been quite incapable of doing so. I'm a respectable girl, and she likes to brag about the fact. But I could be propped up on my elbows at the window, calling out to the passers-by, and she'd just gaze at me and exclaim: "How funny!" I do exactly as I please, from morning to night, and so I deserve some credit for not simply doing whatever takes my fancy, because she certainly wouldn't be the one to hold me back, for all her fine words."

"And so, young lady, the day a prospective fiancé comes forward, you're the one he'll have to talk to?"

"That's right. Why, do you know of any?"
"No."

I was in front of her, sitting in a wooden armchair, the left arm of which was broken. I can still picture myself there, with my back to the window, and a ray of sunshine streaking the floor beside me . . .

All of a sudden she sat herself down on my lap, placed her hands on my shoulders, and asked:
"Is that really true?"

This time I didn't answer.

I'd instinctively put my arms around her, and now with one hand I drew her sweet face, which had assumed a serious expression, towards me; but she forestalled my gesture, and eagerly pressed her burning lips to mine, while giving me a searching look.

Impulsive and incomprehensible: that's the way she's always been, ever since I've known her. The suddenness of her affection intoxicated me like a shot of strong liquor. I hugged her even closer, and her waist yielded to the pressure from my arm. I could feel the warmth and the roundness of her legs pressing down on me through her skirt.

Then she stood up.

"No," she said, "no. Go away."
"Very well, I will – together with you. Come along."
"You want me to leave with you? Where on earth to? To your house? You'd better not count on it, my friend."

I took her in my arms again, but she broke free.

"Don't touch me, or I'll cry out, and then we'll never see each other again."

"Concha ... Conchita ... my sweet – are you mad? What! I come to see you as a friend, I speak to you just as I would to a stranger; all of a sudden you rush into my arms – and then *you* start accusing *me* . . .?"

"I kissed you because I like you; but you can only kiss me if you love me."

"Don't you believe that I love you then, my child?"

"No. You find me amusing and attractive; but I'm not the only one, right, *caballero*? Plenty of girls have black hair, and plenty of girls throw inviting glances as they go by in the street. There's no shortage of them at the Fábrica, just as pretty as I am, and who'll happily let you tell them so. You can go and do what you like with them – I'll even give you some names, if you ask me to. But as for me: I'm me, and there's no-one else like me from San Roque to Triana, and so I've no intention of being bought like a doll at a bazaar, because once I'd been carried off, no-one would ever find me again."

Footsteps could be heard coming upstairs. She turned round, and opened the door to her mother.

"The gentleman came to see how you were," she said. "He thought you were looking a little off-colour yesterday and wondered if you were ill."

*

I left an hour later, feeling extremely tense and irritated, and privately doubting whether I'd ever go back there again.

Alas! I did go back; and not just once, but dozens of times. I was head over heels in love, like a man half my age – you must have known such insane passions yourself. What am I saying! You're experiencing one right now, even as I speak, and so you understand what I'm talking about. Every time I left her room, I'd say to myself: 'twenty-two hours to go' or 'twenty more hours till tomorrow', and those one thousand two hundred minutes always seemed to drag on for ever.

Little by little, I came to spend the whole day with them, like one of the family. I met all their household expenses and even their debts which, to judge from the sums I handed over, must have been considerable. This was really a point in their favour, and what's more there was no gossip about them in the neighbourhood. I'd no trouble in convincing myself that I was the first friend that these poor, solitary women had ever had.

It's true that I experienced little difficulty in getting to be on close terms with them; but then are men ever surprised at the ease with which they seem to get their way? Something that was rather more suspicious, but to which I paid no attention, might have put me on my guard. I refer to the lack of secrecy or formality apparent in their behaviour towards me. I was free to enter their rooms at any hour I chose, and Concha, ever affectionate, if reserved, even let me watch her making her toilette without raising any

objections. In the morning I often found her still in bed, for she'd started getting up late now that she wasn't working any more. Once her mother had gone out, she'd draw her legs up so that her knees were touching, and she'd invite me to sit down beside her on the bed.

Then we'd chat; but I found her inscrutable.

In Tangiers I've seen Moorish women whose costume left nothing uncovered except for a pair of eyes between two veils, but through them I could see right into the depths of their souls. Concha, on the other hand, hid nothing from me – neither her way of life nor her shapely figure – and yet I felt there was a wall between us.

She appeared to love me. Perhaps she really did love me. Even today, I don't know what to think. To all my entreaties, she replied: "Later", and I was unable to break her resolve. When I threatened to leave her, she told me to go ahead. When I threatened her with violence, she said I wouldn't dare. When I showered her with gifts, she accepted them; but her gratitude always remained strictly within bounds.

And yet, when I entered her room, the way her eyes would suddenly light up was anything but deceitful.

She slept for nine hours at night, and for three more in the middle of the day. Apart from that, she did nothing. When she got up, it was to stretch herself out in her peignoir on a cool mat, with a couple of cushions under her head, and another supporting the

small of her back. I could never induce her to occupy herself with anything whatsoever. She hadn't so much as touched a book, a game, or her needlework, ever since the day on which, because of me, she'd left the Fábrica. She wasn't even interested in the household tasks: it was her mother who tidied the apartment, made the beds, did the cooking and, every morning, spent half an hour dressing Concha's thick head of hair – even though my little friend still wasn't properly awake yet.

For a whole week, she refused to leave her bed. It wasn't that she felt unwell; she'd simply discovered that if it was pointless to walk about the streets without good reason, then it was even more futile to take three steps across her room and abandon her sheets for the mat, where the mandatory dress requirements were at odds with her habitual sloth. All Spanish women are like that. Anyone seeing them in public would imagine their fiery glances, loud voices and quick movements all sprang from some perpetually gushing source; and yet, as soon as they find themselves alone, their lives slip by in a state of relaxation which, for them, constitutes their most exquisite pleasure. They stretch themselves out on a *chaise longue* in a room with lowered blinds, and they dream of the jewels they might one day own, the palaces they ought to be living in, and the handsome strangers whose beloved weight they'd like to feel pressing down upon their breast. And so the hours pass.

In her conception of her daily duties, Concha was typically Spanish. But I don't know where on earth

her particular conception of love came from. After twelve weeks of devoted attentions, I still found in her smile both the same promises and the same resistance as before.

*

* *

At last one day, unable to bear this perpetual waiting any longer, nor the incessant anxiety that had so unsettled my existence during the three months that this had been going on as to render it empty and pointless, I took the old woman aside, when Concha wasn't there, and spoke to her quite frankly and in the most pressing terms.

I told her that I loved her daughter, that I intended to join my life to hers, and that although, for obvious reasons, I couldn't agree to any kind of openly acknowledged relationship, I was nevertheless determined to let her share in a deep and exclusive love to which she couldn't possibly take exception.

"I've every reason to believe," I concluded, "that Conchita would love me, if only she didn't distrust me. Should, however, she really feel no love for me at all, then I've no intention of trying to force her to; but if my only misfortune is to have left her in some uncertainty, then will you please talk her round."

I added that, in return, not only would I provide for her now, I'd also furnish her with a private income in the future. And so as not to leave her in any doubt as to the sincerity of my intentions, I presented the old woman with a thick wad of banknotes,

instructing her to use all her maternal experience to convince her child that she wouldn't in any way be deceived.

I returned home more excited than ever. I found it impossible to go to bed that night. Instead, I spent hours pacing up and down the patio. It was a glorious night, and already quite cool, but that wasn't enough to calm me down. I drew up endless plans, in the hope of lighting upon what I was determined should be a happy conclusion to the affair now in hand. At sunrise I had all the flowers cut in three of the beds, and I strewed them along the drive, up the steps and around the entrance to the house, so that her feet should tread a path of crimson and saffron that would lead her right up to me. I pictured her everywhere: leaning against a tree, sitting on a bench, lying on the lawn, looking down over the bannisters or raising her arms in the sunlight towards a fruit-laden bough. The spirit of both house and garden had assumed the form of her body.

And then, after a whole night spent in unbearable waiting, followed by a morning that seemed as if it should never end, I received through the post, towards 11 o'clock, a brief letter. You won't be surprised to hear that I still know it by heart.

This is what it said:

'If you had loved me, you would have waited for me. I wanted to give myself to you; but you asked that I be sold. You will never see me again.

CONCHITA.'

Two minutes later I was heading for Seville on horseback. I arrived before midday had struck, almost in a daze from the heat and my own anxiety.

I rushed upstairs and banged repeatedly on their door.

Silence.

Finally a door on the landing behind me opened, and a neighbour explained to me at great length that the two women had set off in the direction of the station that morning with all their bags, and that no-one even knew which train they'd taken.

"Were they alone?" I asked.

"Yes, all alone."

"There was no man with them, was there? You're quite sure now?"

"Good Lord! You're the only man I've ever seen in their company."

"They didn't leave anything for me, did they?"

"No, nothing. If I'm to believe what they told me, they've fallen out with you."

"Will they be coming back?"

"Heaven knows. They didn't say."

"They'll have to come back for their furniture though."

"I'm afraid not. It's a furnished apartment. They took everything they own with them. And by now, *señor*, they must be miles away."

CHAPTER SEVEN

WHICH ENDS IN A TAILPIECE OF BLACK TRESSES

Autumn passed. Winter came and went. But every detail of these events remained as fresh as ever in my memory, and I can think of few periods in my life as disastrous, or few months as empty, as those were.

I'd thought that I was making a fresh start, that my private love-life was going to be settled for a long time to come, and perhaps for always – and now everything was falling apart before the final ceremony had taken place. I couldn't even call to mind a single hour's genuine intimacy with that little girl; no, nor any particular bond between us, nor anything that had been accomplished or that might enable me to console myself with the vain thought that, even if she were no longer mine, at least she had been mine, and that no-one could take that away from me.

And I loved her! My God, how I loved her! I'd come to believe that she was right, and that I had indeed behaved churlishly towards this young virgin, this figure of legend. If ever I see her again – I told myself – if Heaven grants me that favour, I'll fall down at her feet, and I won't move until she acknowledges my presence, even if it means waiting for years. I won't rush her. I understand how she feels. She knows that women of her condition are usually taken as mistresses by the month, and she wants the

way she's treated to be in keeping with her true worth. She wants to put me to the test, to be sure of me; and, if she gives herself, to give herself freely, and not simply hire herself out. Very well then. If that's what she wishes, I won't disappoint her. But will I ever see her again?

And my old feeling of despair immediately returned.

I did see her again, though.

It was a spring evening. After spending a few hours at the Teatro del Duque, where the incomparable Orejón was performing in several roles, I went outside and, in the silence of the night, I wandered about for a long while in the spacious, deserted Alameda.

As I was returning home along the calle Trajano, alone and having a smoke, I heard someone softly calling my name, and a shudder ran through me, for I recognised the voice.

"Don Mateo!"

I turned round; there was no-one there. And yet I certainly hadn't imagined it.

"Concha!" I shouted, "Concha! Where are you?"
"Sh! – Be quiet, will you! You'll wake mama."

She was speaking to me from a barred window whose stone ledge was roughly on a level with my shoulders. I could see her now, there in her nightclothes, with the two corners of a puce-coloured shawl draped over

her arms, leaning with her elbows on the marble sill behind the iron bars.

"Well, my friend!" she continued in a low voice, "so that's how you've treated me!"

I was quite incapable of defending myself.

"Lean forward," I said. "Further, my sweet . . . I can't see you in the shadow there . . . A bit more to the left now, in the moonlight . . . "

She silently did as I wished, and I gazed up at her in absolute rapture, for I don't know how long.

Then I said:

"Give me your hand."

She held it out to me through the bars, and I lingeringly pressed my lips to her fingers and into her palm, and then all along her warm, naked arm. I was quite delirious. I couldn't believe what was happening. It was her skin, her flesh, her smell . . . It was really and truly *her* that I was holding there beneath my kisses – and after so many sleepless nights!

Then I said:

"Give me your lips."

But she shook her head and withdrew her hand.

"Later."

Oh! That word again! How many times had I heard it already, and now here it was once more, at our very first meeting, like a barrier between us!

I plied her with questions. What had she been doing? Why had she gone away so suddenly? If she'd only said something, I'd have obeyed her every wish.

But to disappear like that, leaving only a short note –
it was too cruel!

"It's your own fault," she replied.

I agreed. But what wouldn't I have owned up to!
Then I fell silent.

All the same, I wanted to know. What had become
of her during the long intervening months? Where
had she been? Since when had she been living in this
house with its iron bars?

"We went to Madrid first, then to Carabanchel,
where we've relatives, and from there we came back
to Seville; and so here I am."

"You occupy the whole house?"

"Yes. It's not very big, but it's still more than
enough for the two of us."

"And how could you afford to rent it?"

"Thanks to you. Mama always put by part of
what you gave her."

"That won't last you for long . . ."

"We've still got enough to go on living here
honestly for another month."

"And afterwards?"

"Afterwards? Do you really believe, my friend,
that I'll be at any loss to know what to do?"

I made no reply; but I could quite happily have
murdered her.

"You misunderstand me," she went on. "If I want to
stay here, I know how to go about it. But who says I

particularly want to? I spent three weeks last year living under the ramparts in the Macarema district. I slept on the ground there, just by the corner of the calle San Luis – you know, where the night watchman stands. He's a good sort, and he'd never have let anyone come near me while I was asleep. There was a bit of flirting, but nothing ever happened to me. I could go back tomorrow if I wanted to. I've got my little patch of grass, and it's not so bad there, believe me. In the daytime I'd work at the Fábrica, or somewhere like that. I expect I could sell bananas, couldn't I? And I know how to knit a shawl, knot tassels for skirts, make up a bouquet, and dance the *flamenco* and the *sevillana*. So don't you worry about me, Don Mateo, I'll get by all right!"

She wasn't speaking loudly, and yet I could hear each word resounding like a commandment in the empty, moonlit street. In fact I wasn't so much listening to her, as watching the movements made by the double line of her lips, whilst her voice rang out in rippling tones as clear as the chiming of convent bells.

Still leaning forward on her elbows, with her right hand thrust into her thick hair and her head supported by her fingers, she continued, with a sigh:
 "Mateo, I'll be your mistress the day after tomorrow."

Trembling all over, I replied:
 "You don't mean it."
 "I do though."

"Then why wait till then, my darling? If you're willing, if you love me . . ."

"I've always loved you."

" . . . then why not right now? See how far apart the bars are from the wall. I could get through between them and the window . . ."

"You can get through that way on Sunday evening. Today I'm blacker with sin than a gypsy, and I don't want to become a woman whilst in such a state of damnation. If you got me pregnant, my child would be cursed for life. Tomorrow I'll tell my confessor everything I've done during the past week, and even what I'm going to do when I'm in your arms, so that he'll give me absolution beforehand – it's safer that way. On Sunday morning I'll go to High Mass and receive Holy Communion, and when the body of Our Lord is in my bosom, I'll ask Him to let me be happy that evening, and loved for the rest of my life. Amen!"

Yes, I know: it's a very strange sort of religion, but it's the only one Spanish women are familiar with. They firmly believe that the Almighty has an inexhaustible supply of indulgences for girls in love who attend Mass, and that if need be He shows them His favour, watches over their beds, and exalts their loins – just as long as they don't forget to tell Him all their most precious secrets. But just imagine if they were right! How many chaste souls would spend eternity weeping over the empty lives they'd led down here on earth!

"Right," Concha said, "leave me now, Mateo. You can see that my room's empty. Don't be jealous or

impatient on my account. You'll find me here late on Sunday night, my lover; but first you're going to promise me that you'll never breathe a word to my mother, and that in the morning you'll leave before she wakes up. It's not that I'm afraid of being seen; I'm my own mistress, as you know, and so I don't need her advice, whether for you or against you. Do I have your word of honour?"

"Just as you wish."

"Good. Be bound by this."

And, tilting her head back, she let her hair tumble down between the bars, like a richly-scented stream. I took it in my hands, I pressed it to my lips, I bathed my face in its warm, dark waves . . .

Then it slipped away through my fingers, and the window banged shut.

CHAPTER EIGHT

IN WHICH THE READER BEGINS TO UNDERSTAND JUST WHO THE PUPPET IS IN THIS STORY

Two interminable days and nights followed. I felt happy, agitated and apprehensive; but I believe that of all the conflicting emotions that were simultaneously unsettling me, it was one of joy, a confused and almost painful joy, that predominated.

I can honestly say that during those forty-eight hours I represented to myself a hundred times 'what was going to happen', as well as the setting, the words and even the silences. I couldn't help playing out in my mind's eye the part that imminently awaited me. I saw myself, with her in my arms. And every quarter of an hour, the very same scene, in all its long, drawn-out detail, kept running through my exhausted imagination.

Finally it was time. I walked up and down her street, not daring to stop beneath her window for fear of compromising her, and yet irritated at the thought of how she was watching me from behind the panes, as she kept me waiting outside in a state of oppressive excitement.

"Mateo!"

At last she was calling me.

And suddenly, like one long dream, my love-life of the last twenty years melted away into thin air and, at that moment, I was a fifteen-year-old boy once

more. I truly believed that, for the very first time in my life, I was going to press my lips hard against a woman's lips, and feel the weight of a warm, young body relaxing in my embrace.

Putting one foot on a stone that protected the base of the wall, and the other on the curved iron bars of the window, I pulled myself up and entered her room like the lover in a stage play, and once inside I hugged her.

She stood there, close against me, both abandoning and withholding herself. As our lips met, we let our heads sink down to one side, eyes closed and nostrils panting for air. And never have I understood so clearly as then, in the dizzy, distracted and oblivious state in which I found myself, just how much truth there is in talk of 'getting drunk on kisses'. I no longer knew who we were, nor anything of what had taken place, nor what would become of us. The present moment was so intense that it swallowed up both past and future. Her lips were moving in response to mine, her body was burning hot between my arms, and, through her skirt, I could feel her little belly rubbing against me in a fervent, lascivious caress.

"I don't feel very well," she murmured. "Wait a bit, I beg you . . . I think I'm going to faint . . . Come out onto the patio with me, and I'll lie down on the cool mat there . . . Be patient . . . I love you . . . but I'm almost unconscious . . ."

*

I made for one of the doors.

"No, not that one. That's mama's room. It's through here. Come along, I'll show you the way."

The white patio outside was dominated by a star-studded expanse of black sky, across which drifted wisps of bluish cloud. One floor of the building was entirely bathed in moonlight, but the rest of the courtyard lay plunged in intimate shadow.

Concha stretched herself out on a mat in Oriental fashion. I sat down beside her, and she took my hand.

"My friend," she said, "Do you love me?"

"As if you needed to ask!"

"But how long will you love me for?"

I dread these questions, which all women ask, and to which one can only reply with the worst sort of platitudes.

"And when I'm no longer so attractive, will you still love me then? ... And when I've grown old, terribly old, will you love me even then? Tell me you will, my darling. Even if it's not true, I need you to tell me that it is, and to give me strength. You see, I promised you that it would be this evening, but I'm really not sure whether I feel up to it ... or even whether you deserve it. Ah! Holy Mother of God! If I were wrong about you, I think my whole life would be ruined as a result. I'm not like those girls that go with any Tom, Dick or Harry. After you, I'll never love anyone else, and if you ever left me, it would all but kill me."

She bit her lip with a suppressed moan, and gazed

out into empty space; but then her expression soft-
ened, and she broke into a smile.

"I've grown in the last six months," she said. "I
can't even do up last summer's bodices any more.
Open the one I'm wearing now, and you'll see how
lovely I've become."

Had I asked, she'd almost certainly have refused,
for I was beginning to doubt whether this night so
far spent in talking would ever be spent in making
love.

But I was no longer touching her, and so she
moved closer.

Alas! The breasts that I laid bare when I
unfastened her straining bodice were like fruits of
the Promised Land. There may be others as beautiful
– I really couldn't say. As for hers, I never saw them
match their shape of that evening. Breasts are living
beings; they have their infancy and their decline. I
firmly believe that I saw hers in their fleeting
moment of perfection.

Meanwhile she'd drawn out a scapular of new cloth
from between them, and was kissing it piously whilst
observing my emotion out of the corner of one half-
closed eye.

"Well, do you like what you see?"

I took her in my arms again.

"No, not just yet."

"Now what's wrong?"

"I'm not in the mood, that's all."

*

And she did up her bodice.

I was suffering dreadfully; and now I was pleading with her, almost brutally, as I struggled against her hands, that had once more become protective. I could have caressed and ill-treated her at the same time. This stubborn insistence on both seducing me and spurning me, this little game that had been going on for a year already and that intensified at the decisive moment, just when I was expecting the final outcome, was simply trying my patience and undermining my tender feelings.

"My dear child," I said, "you're making fun of me, but take care lest I grow tired of it."

"So that's the way it is, eh? Well, in that case, you'll get no love from me today, Don Mateo. Till tomorrow, then."

"I won't be coming back."

"You'll be back tomorrow."

Furious, I put my hat on and left, fully determined never to see her again.

I kept my resolution until the moment I fell asleep, but on waking up next morning I felt utterly miserable.

Nor have I forgotten what a terrible day followed!

Despite my inward vow, I set off along the road to Seville. An irresistible force drew me towards her. I believed that my will had ceased to exist, and I no longer had any control over the direction in which my feet were taking me.

For three hours I struggled feverishly with myself

as I paced up and down the calle Amor de Dios, the street behind the one Concha lived on, forever on the verge of crossing the twenty yards that separated me from her. Finally I triumphed. I left town almost at a run, without having banged on my beloved's window. But what a wretched victory it was!

Next day, she was at my house.

"As you didn't want to call on me, I've come round to see you myself," she said. "So do you still say that I don't love you?"

I could have thrown myself at her feet, sir.

"Quick now, show me your bedroom," she added. "I don't want you accusing me of indifference today. Do you imagine that I'm not just as impatient as you are? You'd certainly be surprised if you knew what I was really thinking."

But as soon as she entered the room, she changed her mind:

"No, not this one, in fact. There've been too many women in this nasty bed already. It's hardly a suitable room for a young virgin. Let's try another one, shall we? A spare room that nobody uses."

That meant having to wait for another hour, for the windows had to be opened, the bed made, and the room swept out.

At last everything was ready, and we went upstairs.

I wouldn't go so far as to say that this time I felt absolutely certain of success, but I had my hopes,

nonetheless. After all, here she was, alone in my house, and fully aware of my feelings towards her, against which she had no means of protecting herself. It seemed unlikely that she'd have taken such a risk unless she'd already imagined herself making the sacrifice that she now claimed to be offering me.

As soon as we were alone, she unfastened her mantilla, which was attached to her hair and her bodice with fourteen pins, and then, quite simply, she started to undress. I must confess that instead of assisting her in this lengthy operation, I rather slowed things down, interrupting her a score of times in order to kiss her bare arms, her fleshy shoulders, her firm breasts and the dark brown nape of her neck. I watched her skin gradually appearing around the edges of her linen underclothing, telling myself that this rebellious young body was finally going to surrender to me.

"Well, have I kept my promise then?" she asked, pulling her chemise in tightly at the waist, as if wishing to emphasise the suppleness of her figure. "Close the blinds, will you? It's horribly bright in here."

I did as she asked; meanwhile she silently lay down in the middle of the large, deep mattress. I could see her through the white mosquito netting, looking like an apparition in a stage play behind a gauze curtain.

What more can I say, sir? As you've doubtless guessed, this time as well I was tricked and made to look ridiculous. I've already told you that this girl is

the worst of women, and that her cruel inventiveness knows no bounds, but as yet you hardly know her. It's only now, by following my story scene by scene, that you're going to find out what Concha Pérez is really like.

So, she'd come to my house in order, she said, to give herself to me. You've heard her promises and her loving words. Right up to the very last moment she behaved like an amorous maiden who's about to experience the delights of love; almost, in fact like a young bride receiving her husband for the first time – a bride far from ignorant, I grant you, but nevertheless solemn and apprehensive.

Well now, when getting dressed at home, the little wretch had rigged herself out in a pair of short drawers made from some sort of sailcloth that was so stiff and so strong that not even a bull's horn could have broken through it, and which were tightly laced up around her waist and the middle of her thighs with knots of unassailable toughness and intricacy. And so that's what I discovered, then, in the midst of my most violent longing, whilst that vile creature, without so much as turning a hair, explained:

"I'll be as foolish as God wishes; but not as much as men desire!"

For a moment I thought I might strangle her, but then – and I'm not ashamed to admit it – I put my head in my hands and wept.

What I was weeping for, sir, was my own youth, whose irretrievable loss had just been proved to me

by that child. Between the age of twenty-two and thirty-five there are certain humiliating affronts to which no man is ever subjected. I couldn't believe that Concha would have treated me like that had I been ten years younger. As for those drawers, that barrier between love and me, I felt that henceforth all women would seem to be wearing a pair, or at least would wish for one before coming anywhere near my embrace.

"That's enough," I said. "I've understood. Now leave."

But she suddenly became alarmed, and now it was her turn to enfold me in her sturdy little arms, which I had some difficulty in pushing away, as she sought for my lips, saying:

"My sweet, can't you just be satisfied with loving everything I've already given you? You have my breasts and my lips, my burning legs and my fragrant hair – my entire body is yours to hold and caress, and you've my tongue when I kiss you. Isn't that enough, all that? In that case, perhaps it's not me that you love, but only what I refuse to let you have? Any woman can give you that, so why ask it of me, of someone who resists? Is it because you know I'm a virgin? I can think of others, even in Seville. I swear I can, Mateo. Ah! Come now, my darling – love me as I wish to be loved, by degrees, and be patient! You know that I'm yours, and that I'm keeping myself for you alone. What more do you want, my sweet?"

It was decided that we'd go on seeing each other,

either at her house or at mine, and that she'd have her own way in everything. In return for a promise from me, she agreed not to put her hideous piece of canvas armour on again; but that was all that I obtained from her, and even so, the first night she didn't wear it, it seemed to me that my torment was only intensified as a result.

Such, then, was the degree of servitude to which that child had reduced me. I won't dwell on the incessant demands for money that punctuated her conversation and to which I always gave in – but even leaving that aside, the nature of our relationship is still of particular interest. Thus every night I held in my arms the naked body of a fifteen-year-old girl who may have been brought up by the nuns, but whose social status and moral disposition ruled out any idea of physical purity on her part. And yet this girl, in other respects as ardent and passionate as one could wish, behaved towards me as if nature itself had somehow prevented her from ever being able to satisfy her desires.

There could be no conceivable excuse for putting on such an act, and none was given. You'll be able to guess the reason for this yourself, later on. Meanwhile I went on allowing myself be made a fool of in this way.

For make no mistake, my young French friend, reader of novels and participant, perhaps, in private intrigues with the dissolute virgins found in spa towns – when it comes to love, Andalusian women have neither taste nor instinct for anything that is in

any way artificial. They're wonderful lovers, but their senses are so keen that they're unable to endure the shrill warbling of superfluous decoys without it driving them into a frenzy. Nothing ever happened between Concha and me, nothing at all. Do you understand what I'm saying? Nothing! And this went on for two whole weeks.

On the fifteenth day, as she'd received from me the night before the sum of five thousand pesetas to pay her mother's debts, I found their house empty.

CHAPTER NINE

IN WHICH CONCHA PÉREZ UNDERGOES HER THIRD METAMORPHOSIS

It was too much.

Henceforth that cunning little hussy's soul held no more secrets for me. I'd been thoroughly taken in, and it left me feeling even more ashamed than distressed.

Blotting the perfidious child out from my past life, I attempted to forget all about her overnight. It was one of those paradoxical intentions whose inevitable failure women always anticipate.

I left for Madrid, determined to take as my mistress the first attractive young woman who should chance to catch my eye.

It's the classic stratagem, one that everybody hits upon, and that never succeeds.

My search took me from salon to salon, and then from theatre to theatre. In the end I found an Italian dancer, a big girl with muscular legs who'd have been an extremely handsome addition to someone's harem, but who certainly didn't possess the qualities one's looking for in one's sole intimate lady friend.

She did her best. She was affectionate and easy-going. She taught me various Neapolitan vices with which I was unfamiliar and which she enjoyed more than I did. I could see that she was doing her utmost to keep me with her, and that concern for her

material wellbeing wasn't the only reason for her fierce, loving devotion.

Alas! If only I could have loved her! I'd nothing to complain of as far as she was concerned. She was neither unfaithful nor importunate. She seemed to be unaware of my failings. She didn't cause me to fall out with my friends. And finally, her jealousies, though frequent, were only hinted at, and never openly expressed. Such a woman cannot be appreciated too highly.

But I felt nothing for her whatsoever.

For two months I forced myself to live under the same roof as Giulia, sharing the air she breathed as well as the room she occupied in the house that I'd rented for us both at one end of the calle Lope de Vega. But I didn't so much as look at her when she came in, walked about, or even passed right in front of me; nor did the sight of the petticoats, dancer's tights, drawers and chemises, that lay strewn about over the sofas, stir me in any way. For sixty nights I saw her dark brown body stretched out beside mine in an oppressively close bed in which, as soon as the light was out, I imagined another's presence.

Finally, in self-despair, I fled.

I returned to Seville. My house seemed to have a sepulchral air about it. I left for Granada, where I got bored; for Cordoba, which was torrid and deserted; for dazzling Jerez, everywhere redolent of its wine cellars; for Cadiz, an oasis of dwellings set in the sea.

Throughout this trip, sir, I was guided from town to town not by my own fancy, but as one in the grip of a distant and irresistible enchantment, in which I believe as firmly as I do in the existence of God. I've run into Concha Pérez four times now in this vast country, and it hasn't just been a series of chance encounters. I don't believe in those rolls of the dice that are supposed to govern our destiny. I *had* to fall into that woman's clutches again, just as I *had* to go through everything that you're going to hear about.

And, indeed, it all took place just as fate had decreed.

*
* *

It happened in Cadiz.

One evening I entered the local *baile*, or dance hall, and there she was, sir, dancing in front of thirty-odd fishermen, as many sailors, and a few stupid foreigners.

As soon as I saw her, I began to tremble. I must have looked as white as a sheet, and I felt winded and drained of strength. I sat down on the nearest bench, which was next to the door and, putting my elbows on the table, I gazed at her from afar, as at someone who'd risen from the dead.

She was still dancing away, hot and breathless, with her face crimson and her breasts bouncing around wildly, as she waved her deafening castanets about in

111

each hand. She didn't look at me, but I was sure that she'd seen me. She was bringing her *bolero* to a close in a movement of furious passion, the provocative thrusts of her legs and bust aiming randomly at someone in the crowd of spectators.

Suddenly she stopped, amidst roars of approval.

"Bravo!" the men shouted. "Bravo! Isn't she lovely! Bravo, my girl! Bravo! Encore!"

Hats were sent spinning onto the stage. The entire audience was on its feet now. Still panting, she bowed to them, with a little smirk of triumph.

As is customary, she then came down off the stage in order to take a seat somewhere among the drinkers, whilst another dancer replaced her in front of the footlights. And, knowing full well that in the corner of the room there was a being who adored her, who'd have prostrated himself at her feet for all the world to see, and who was suffering unspeakably, she nevertheless went from table to table, and from one man's arm to another's, right before his very eyes.

They all knew her by name, and I heard cries of "Conchita!" that sent shivers running up and down my spine. They gave her drinks and they touched her bare arms. She put a red flower that a German sailor offered her in her hair, she tugged the braided locks of a bullfighter who was playing the fool, she pretended to behave voluptuously in front of a young fop who was sitting with some women and she caressed the cheek of a man that I'd have liked to kill.

*

I haven't forgotten a single gesture that she made during this atrocious manoeuvre, which went on for fifty minutes.

A man's past is filled with memories such as these.

She stopped at my table last of all, because I was sitting at the back of the room – but she came over nonetheless. Was she embarrassed? Did she try to act surprised? Oh! Not at all! Not her! She sat down in front of me, clapped her hands to attract the waiter's attention and shouted out:

"Tonio! A cup of coffee!"

Then, displaying the most exquisite composure, she looked me straight in the eye.

"Aren't you afraid of anything, Concha?" I asked, very quietly. "Aren't you afraid of dying?"

"No. Besides, if anyone's going to kill me, it certainly won't be you!"

"Are you defying me to, then?"

"Right here, or anywhere you please. I know you, Don Mateo, as if I'd had to carry you for nine months. You'll never touch a hair of my head; and you're quite right, for I *don't* love you any more."

"You actually have the nerve to say that you once loved me?"

"You can think what you like. You've only got yourself to blame."

So now *she* was reproaching *me*! I should have expected some such nonsense.

"That's twice now," I went on, "twice that you've done that to me. What I gave you came from the

bottom of my heart, but you received it like a thief
and took off without a word, without a letter, with-
out even asking anyone to come and bid me farewell
on your behalf. What have I done that you should
treat me like that?"

And I muttered several times under my breath:
"Wretch! Wretch!"

But she was ready with her excuse:

"What have you done? You've broken your word,
that's what. Didn't you swear to me that I'd be safe
in your arms, and that you'd let me choose on which
night and at what hour I'd commit my sin? But last
time – don't you remember? – you thought that I
was asleep, and that I couldn't feel anything. But I
was awake, Mateo, and I realised that if I spent
another night by your side, I wouldn't get to sleep
without you surprising me into giving myself to
you. And that's why I ran away."

It was quite absurd. I just shrugged my shoulders.

"So that's what you reproach me for," I said, "when I
can see for myself the sort of life you lead, and the
men who share your bed."

"That's not true!" she replied furiously, rising to
her feet. "I forbid you to say that, Don Mateo! I
swear to you on my father's grave that I'm as pure
and innocent as a new-born child – and also that I
hate you for having doubted it!"

I found myself alone. A few moments later I got
up and left as well.

IN WHICH MATEO FINDS HIMSELF PRESENT AT AN UNFORESEEN SPECTACLE

All night long I wandered up and down the ramparts. The incessant sea wind cooled my feverishness and dispelled my cowardice. Yes, I'd felt like a coward in front of that woman. I could only blush with shame at the thought of us both, and I mentally subjected myself to the worst possible insults. And, what's more, I foresaw that I'd still deserve them every bit as much the following day.

After what had happened, there were only three courses of action open to me: to leave her, to force her, or to kill her.

I chose the fourth, which was to submit to her.

Every evening I returned to my seat, like an obedient child, in order to watch and wait for her.

Little by little she calmed down, by which I mean that she no longer bore me any grudge for all the wrong she'd done me. Immediately backstage there was a large white room where the dancers' mothers and sisters dozed while waiting for them to finish. Concha allowed me to stand there too, by a special privilege that each of these young girls could bestow on her chosen sweetheart. All in all, delightful company, wouldn't you say?

The hours I spent there were particularly miserable. You know me: I've never been the sort to spend

117

my life propped up on my elbows in cheap taverns, and to do so now made me loathe myself.

Señora Pérez was there, like the others. She didn't seem to know anything about what had happened in the calle Trajano. Was she lying too? I didn't even care. I listened to her confidences, I paid for her brandy . . . But let's not talk about that any more, if you don't mind.

The only joy I experienced came from Concha's four dances, when I would stand in the open doorway through which she made her entrance and, during those rare moments when her movements required her to turn her back on the audience, I'd have the fleeting illusion that she was facing, and dancing for, me alone.

Her greatest success came in the *flamenco*. What a dance that is, sir! What tragedy it expresses! It's a passionate love story in three acts: desire, seduction, and final enjoyment. No stage play ever conveyed the nature of woman's love with the intensity, the grace, or the fury of these three consecutive scenes, in which Concha was quite incomparable. Do you fully understand the drama that's being played out? Anyone who hasn't already seen it at least a thousand times would need to have it explained to them afresh. They say that it takes eight years to train a flamenco dancer and, given the precocious maturity of our women, that means that by the time they're old enough to know how to dance, they're no longer beautiful. But Concha was a born *flamenca*; it came from intuition, not experience. You know how it's

danced in Seville. You're familiar with our best *baila-rinas*, and none of them is perfect, for this exhausting dance, which lasts a full twelve minutes – and just try to find me an opera dancer who'd agree to a twelve-minute variation! – comprises three successive rôles which have nothing in common: the lover, the ingénue and the tragédienne. It requires a sixteen-year-old to mime the second part, in which Lola Sánchez is currently performing wonders with her sinuous gestures and her graceful attitudes, and it requires a woman of thirty to act out the conclusion to the drama, in which La Rubia, despite her wrinkles, still excels every evening.

Conchita is the only woman I've ever seen remain consistently true to form throughout the entire length of this formidable undertaking.

I can still picture her there, advancing and retreating with short, rhythmical steps, peering out sideways from beneath an upraised sleeve and then, with a movement of the hips and torso, slowly lowering her arm, above which would appear a pair of dark eyes. Yes, there she is: delicate or passionate, her eyes bathed in languor or sparkling with humour, striking the boards of the stage with her heel, or making her finger-tips crackle at the end of her gesture, as if to provide a life-giving cry for each of her undulating arms.

When she'd finished, she'd come off in a state of excitement and exhaustion that only enhanced her beauty. Her flushed face would be covered in sweat, but her bright eyes, quivering lips and young heaving

bosom all combined to lend an expression of exuber-
ance and abiding youthfulness to her upper body. In
short, she was radiant.

For a month our relationship remained on this foot-
ing. She tolerated my presence in the back room,
behind the platform where she performed, but I
wasn't even allowed to see her home afterwards, and
I only kept my place beside her on the condition that
I wouldn't reproach her in any way, either with
regard to the past or to the present. As to the future
– I don't know what her thoughts were on the sub-
ject, but for my part I was at a loss for any solution
to this pitiful affair.

I was vaguely aware that she lived with her mother
in the town's only working-class suburb, near the
Plaza de Toros, in a large white and green house that
they shared with six other *bailarinas* and their fam-
ilies. I hardly dared imagine what might be going on
in such a city of women. And yet our dancers lead a
well-ordered existence. From eight in the evening
until five in the morning they're on stage, and when
they get home at dawn, utterly exhausted, they
sleep, often all alone, till mid-afternoon. So that only
really leaves the early evening for them to take
advantage of, and even then fear of the ruin that
would result from falling pregnant holds these poor
girls back. Besides which, they'd never be able to
bring themselves each evening to add to the strain of
an already arduous night with any further exertions.

*

Nevertheless, I couldn't help feeling anxious. A couple of Concha's friends, who were sisters, had a younger brother who shared their room with them, or else those of their neighbours, and he aroused a good deal of jealousy, as I myself witnessed on several occasions.

He was known as *El Morenito*, on account of his dark complexion. I never learnt his real name. Concha used to invite him over to our table, feed him at my expense, and help herself to my cigarettes, which she then placed between his lips.

Any display of impatience on my part was met with a shrug of the shoulders, or an icy remark that made me suffer more than ever.

"Morenito belongs to everyone," she'd say. "But if I took a lover, he'd be mine as surely as the ring on my finger, and you'd know about it, Mateo."

I never made any reply. Besides, the stories going around concerning Concha's private life portrayed her as being irreproachable, and I so wanted to believe this was true that I accepted on trust even the most groundless rumours to this effect. No man ever came up to her wearing the distinctive expression of a lover meeting in public the woman he'd been with the night before. I had a few quarrels on account of her with various suitors, who doubtless found my presence rather annoying, but never with anyone who boasted of having enjoyed her. I tried on several occasions to get her friends to talk, but they always replied: "She's a virgin. And she's quite right to stay that way."

As far as she was concerned, there was never any question of a reconciliation between us. She didn't ask me for anything, nor did she accord me anything. Once so cheerful, she'd grown serious and she hardly ever spoke any more. It would have been a waste of time trying to interpret the look in her eyes, for I could no more read what was going on in her secretive little soul than what lies behind a cat's inscrutable stare.

*
* *

One night, on a signal from the manageress, she left the stage along with three of the other dancers and went upstairs to the first floor, in order, she told me, to take a siesta. She'd often disappear like this for an hour or so, but I never let it upset me for, despite all her lying and deceitfulness, I implicitly believed her every word.

"When we've had to do a lot of dancing," she explained, "we're made to go and take a nap. Otherwise we'd start nodding off on stage."

So once again she'd gone upstairs and, feeling in need of some fresh air, I went outside for half an hour.

On my way back into the hall I met one of the other dancers in the corridor, a rather simple-minded girl from Galicia, nicknamed *La Gallega*, who happened to be rather tipsy that night.

"You've come back too early," she said.

"Why's that?"

"Conchita's still upstairs."

"I'll wait for her to wake up, then. Let me get past, will you."

She didn't seem to understand.

"For her to wake up?"

"Of course. What's the matter with you?"

"But she's not sleeping."

"She told me . . ."

"She told you she was going to have a nap? Ah! Well, that's all right then!"

She did her best to contain herself, but however hard she tried, and in spite of keeping her lips tightly pursed, she was unable to stifle the roar of laughter that now welled up inside her.

Deathly pale, I grabbed hold of her arm, and shouted:

"Where is she? Tell me at once!"

"Don't hurt me, *caballero*. She's showing her belly button to some foreigners. Honest to God, it's not my fault. If I'd known, I wouldn't have told you. I don't want to fall out with anyone. I'm a good girl, *caballero*."

Believe it or not, I remained quite impassive. I just felt a terrible chill spreading through me, as if a draught of dank cellar air had crept in beneath my clothes. My voice wasn't trembling, though, when I said:

"Gallega, take me upstairs."

But she shook her head.

"No-one will ever know you've spoken with me," I went on. "Quickly now . . . She's my sweetheart, you see . . . I've every right to go up there . . . Show me the way."

And I pressed a gold coin into her hand.

A moment later I was standing alone on the balcony of an inner courtyard, looking in through a pair of French windows, where a hellish sight met my eyes.

Inside there was a second room for dancing, smaller but very well lit, with a platform and two men playing guitars. In the middle Conchita, naked, was dancing a frenzied *jota*, along with three other nude, nondescript girls in front of a couple of foreigners who were sitting at the back. In fact she was more than naked. She had on long black stockings that came right up to the top of her thighs, like the legs on a pair of tights, whilst on her feet she was wearing little shoes that made the wooden floor ring out as they struck it. I didn't dare interrupt. I was afraid I might kill her.

Alas! Never, but never, have I seen her looking so beautiful! It wasn't because of her eyes or her fingers this time; no, her entire body now seemed as expressive as someone's face — more so, in fact — and her head, swathed in hair, hung down over her shoulder like a useless object. Smiles hovered in the folds of her hips, blushes coloured the curves of her sides, and her breasts seemed to be staring straight ahead through two large, dark, and unblinking eyes. No

124

indeed, never have I seen her looking so beautiful. Dresses have creases that spoil a dancer's expression and cause her graceful outline to twist round the wrong way; but now, in a kind of revelation, I could see the gestures, vibrations, and movements of her arms and legs, of her supple body and her muscular back, endlessly emerging from a single visible source, which lay at the very centre of the dance: her little brown and black belly.

Then I broke down the door.

Just to look at her for ten seconds, and swear to myself that I wouldn't murder her, had been too much for my will-power to stand. And now nothing was going to hold me back.

I entered to a chorus of shrill screams, and went straight up to Concha.

"Follow me," I said to her curtly. "Don't be afraid. I'm not going to hurt you. But come with me this instant, or else woe betide you!"

But, oh no! She wasn't afraid of anything! She backed up against the wall, and there, stretching her arms out on either side of her, she cried:

"I'll no more move from here than Christ did from the Cross! I won't! And you won't lay a finger on me either, because I forbid you to come any nearer than that chair."

Then, turning to the manageress, she added:

"Leave me now, madam. And the rest of you – go downstairs. I don't need anyone's help. I can take care of him!"

CHAPTER ELEVEN

HOW THERE SEEMS TO BE AN EXPLANATION FOR EVERYTHING

They left the room. The foreigners were the first to make themselves scarce.

Up until then, sir, I'd have called any man who was supposed to have hit a woman a scoundrel. And yet, faced with that woman there, it's a mystery to me how I managed to contain myself. My hands kept opening and closing again, as if around someone's throat, strangling them. A gruelling struggle was going on inside me between my will-power and my wrath.

Ah! This immunity with which we shield women is surely the ultimate sign of their omnipotence. If a woman insults you to your face and hurls abuse at you – bow to her. If she hits you – protect yourself, but make sure she doesn't get hurt. If she's ruining you – let her get on with it. If she's unfaithful to you – keep quiet about it, lest you compromise her. If she wrecks your life – please go ahead and kill yourself! But, above all, never, through any fault of your own, allow the skin of these fierce, exquisite beings, for whom the pleasures of evil almost surpass those of the flesh, to suffer any kind of painful sensation, however fleeting.

The Orientals – those great voluptuaries – don't treat them with the same consideration as we do.

They've cut off their claws, in order to soften the look in their eyes. They bridle their malevolence, the better to unleash their sensuality. I admire them.

But, as far as I was concerned, Concha remained invulnerable.

I didn't go any closer. I stayed about three paces away and spoke to her from there. She was still standing up against the wall, perfectly straight above her long black stockings, like a flower in a slender vase, with her hands clasped behind her back, her chest thrust forward, and her feet together.

"Well then," I began, "what have you got to say for yourself? Come on now, make something up! Defend yourself! Lie to me again – after all, you do it so well!"

"Oh! Now isn't that just marvellous!" she exclaimed. "*You're* accusing *me*! You come in here through the window, like a thief, smashing everything, and then you threaten me, you disrupt my dance, you force my friends to leave . . ."

"Shut up!"

" . . . You'll very likely get me dismissed from here too – and now I'm the one who has to explain myself! Of course, it was me who did all the damage, wasn't it? And this ridiculous scene – I suppose it's me who provoked it! Oh! Just leave, will you? You're too stupid for words!"

And as, after her lively dance, beads of sweat were welling up from a thousand different points all over her glistening skin, she took a towel out of a side-

board and rubbed herself up and down, from her belly to her head, as if she'd just stepped out of the bath.

"And so," I resumed, "that's what you've been up to in the very building in which I come to see you! That's what you do for a living! That's the woman I love!"

"That's right. And you knew nothing about it, did you, you simpleton?"

"Me?"

"But no, of course you didn't! Everyone in Spain talks about it, they know about it in Paris and Buenos Aires, and in Madrid even a twelve-year-old child can tell you that in the leading dance hall in Cadiz, the women dance stark naked. But you, who are forty years old, who aren't married, you expect me to believe that no-one had told you about it!"

"I'd forgotten."

"He'd forgotten! You've been coming here for two months, you've seen me go upstairs to the little room four times a week . . ."

"That's enough, Concha; you're making me suffer atrociously."

"So now you know what it's like! I'll get my revenge for what you've done to me this evening, Mateo, because you're behaving spitefully, out of stupid jealousy, and I'd like to know by what right! After all, who are you to treat me like this? Are you my father, eh? – No! Are you my husband? – No! Are you my lover . . .?"

"Yes! I'm your lover! I am!"

"Indeed! Well, you make do with very little for your pains!"

And she burst out laughing.

"Concha, my child," I said, paling terribly once again, "speak to me, tell me now: is there anyone else? If you already belong to another, I swear I'll leave you. Just say the word."

"I belong to no-one but myself, and right now that's the way it's staying. I'm the most precious thing I have, Mateo, and no-one's rich enough to make me part with myself."

"But those men, those two men who were here a moment ago . . .?"

"What is it now? Do you suppose I know who they are?"

"Is that really true? You don't know them?"

"No, of course I don't know them! Where on earth do you think I could have met them? They're just a couple of foreigners who arrived here with a hotel guide, that's all. They're leaving for Tangiers tomorrow. I've hardly compromised myself, my friend."

"And what about here? Right here?"

"Really now, just look around you: is this a bedroom? Search the whole building: is there a bed anywhere? And besides, you saw them yourself, Mateo. They were dressed up like dummies, sitting there with their hats on their heads and their chins resting on their canes. You must be mad, I tell you, absolutely mad to make such a scene when I haven't done a single thing for which you can reproach me."

*

Even had she defended herself much worse than that, I believe I'd still have made excuses for her, so greatly did I crave forgiveness. I was only afraid that she might actually own up to something.

One final question was already tormenting me.

As I asked it, I was trembling all over:

"And Morenito? . . . Tell me the truth, Concha. This time I really want to know. Swear that you won't try to hide anything from me, and that if there's anything between you, you'll tell me everything. Please, my dear child, I beseech you!"

"Morenito? He was in my bed this morning."

For a moment everything went black, and then my arms closed around her and I hugged her tightly, hardly knowing myself whether I wanted to smother her or ravish her from some imaginary rival.

She realised this, and laughingly cried out:

"Let go! Let go of me, Mateo! For a minute there you were becoming dangerous. You might have had me against my will, in a fit of jealousy. That's better. Now, stay where you are! I'm going to explain . . . But there's no need to tremble like that, my poor friend, really there isn't."

"Is that so?"

"Morenito lives with his two sisters, Mercedes and Pipa. They're very poor. There's only one bed for the three of them, and it's not very big. So, since the weather's been so hot lately, they prefer to sleep less tightly squashed together after their eight hours' dancing, and they send the little lad to stay with the other girls in the house. This week mama's taking

part in the Perpetual Adoration at the parish church. She's not at home when I'm in bed, and so Mercedes asked me if I had any room for her brother, and I said yes. I don't see that there's anything for you to get worried about."

I looked at her without replying.

"Oh!" she went on, "If that's still what's bothering you, you can set your mind at rest! I no more yield to him, you know, than do his sisters. Honestly – I give you my word. He barely even kisses me four or five times before going to sleep, and then I turn over with my back to him, as if we were married."

She pulled her stocking back up over her right thigh, then slowly added:

"As if I were with you."

The thoughtlessness, impudence or plain craftiness of that woman – for I really didn't know what to make of her – left me feeling utterly bewildered, and conscious only of my own mental suffering. In fact, I was even more unhappy than uncertain; but this unhappiness was too unbearable for words.

I very gently took her onto my lap. She didn't try to stop me.

"Listen to me, my child," I said. "I can't go on living according to your whims as I've been doing for the past year. You must speak to me quite frankly now, and perhaps for the last time. I'm suffering terribly, and if you spend another day in this dance hall, or even in this town, you'll never see me again. Is that what you want, Conchita?"

*

"You've never understood me, Don Mateo," she replied, in a voice so changed that it was like listening to a completely different woman. "You thought that you were chasing after me and that I was withholding myself from you, when, on the contrary, it's I who love you, and want you to be mine for the rest of my life. You remember at the Fábrica? Was it you who accosted me? Was it you who took me away from there? No. It was I who ran down the street after you and dragged you along to my mother's, keeping you there almost forcibly, I was so afraid I might lose you. And next day . . . Do you remember that too? You came in. I was alone. You didn't even kiss me. I can still picture you, in the armchair, with your back to the window . . . Then, throwing myself upon you, I held your head in my hands, and your lips to mine, and – I've never told you this before – but I was very young then, and it was during that kiss, Mateo, that for the first time in my life I felt a sensation of pleasure melting inside me . . . I was sitting on your lap, just as I am now . . ."

Overcome with emotion, I held her close. She'd won me back, just like that, with a few words. She was simply toying with me, in whatever way she saw fit.

"I've never loved anyone but you," she went on, "ever since that December night when I saw you in the train, just after I'd left my convent in Avila. At first I loved you because you're handsome. Your eyes are so bright, and have such a tender expression in them, that I was sure that every woman you'd met must have fallen in love with them too. If you only

135

knew how many nights I've spent thinking of those eyes of yours! But later on I came to love you most of all because of your goodness. I wouldn't have wished to join my life to that of a man who was selfish as well as handsome, for, as you know, I'm far too self-centred myself to accept ever being anything less than completely happy. No; I wanted all the happiness I could get, and I soon realised that if I asked you, you'd make this possible."

"But then why this long silence, my precious?"

"Because what's good enough for other women still doesn't satisfy me. Not only do I want all the happiness, I also want it for all the rest of my life. I want to marry you, Mateo, so that I'll be able to go on loving you when you no longer love me. Oh, don't be alarmed! We won't go to the church, nor before the mayor. I'm a good Christian, but I know that God smiles on true love, and I'll get to Heaven ahead of plenty of women who are married. I won't ask you to wed me publicly, because I know that's out of the question. You'll never address the woman who danced naked in this dreadful hovel, in front of all the foreigners who passed through here, as Doña Concepción Pérez de Díaz . . ."

And she burst into tears.

"Concepción, my child," I went, deeply moved, "calm yourself, now. I love you. I'll do whatever you want."

"No!" she cried, giving a sob. "No, I don't wish it! It's impossible! I don't want you to sully your good name by adding mine to it. And so now, you see, I can no longer accept your generosity. In the eyes of the

world, Mateo, we won't be married; but you'll treat me as if I were your wife, and you must promise never to abandon me. I'm not asking for much: just a little house of my own, somewhere close to you. And a dowry. The same dowry you'd give to the woman you were going to marry. I've nothing to offer you in return, my darling. Nothing except my undying love – along with my virginity, that I've kept for you in spite of everyone."

SCENE BEHIND A CLOSED IRON GATE

Never before had she spoken to me in such a touching and unaffected way. I believed that I'd finally succeeded in releasing her true soul from behind the proud, ironic mask that had kept it hidden from me for too long, and with my moral recovery, a new life opened out before me.

(By the way, do you happen to know that remarkable painting by Goya in the Madrid art gallery, the first on your left as you enter the room on the last floor? Four women in flounced skirts, standing on a garden lawn, are holding out a shawl by its four corners and, laughing all the while, are bouncing a man-sized puppet up and down on it . . .)

Anyway, we returned to Seville.

By now she'd recovered her mocking voice and her distinctive smile; but I no longer felt worried. A Spanish proverb tells us that "Women, like cats, belong to whoever takes care of them". I took excellent care of her, and I was just happy that she should let me do so!

I'd managed to convince myself that she'd never swerved from the path that had led her to me; that she'd really been the one who'd accosted me and then, little by little, seduced me; and that her twice running away could be accounted for not, as I'd

suspected, by wretched material calculations, but by my own misconduct, mine alone, and by my neglecting my obligations. I even forgave her for her indecent dancing, telling myself that at the time she'd despaired of ever being able to live out her dream with me, and that in Cadiz a young virgin can scarcely earn a living without assuming at least the appearance of a woman of pleasure.

But what can I say? I loved her.

On the very day of our return, I found a large house for her in the calle Lucena, in front of the parish church of San Isidorio. It's a quiet district, virtually deserted in summer, but cool and shady. I could see her being happy in this yellow and mauve street, not far from the calle del Candilejo, where Carmen entertained Don José.

The house needed furnishing. I wanted to get it done quickly, but she was terribly capricious. An interminable week went by amidst decorators and removal men. But for me it was like a week of wedding festivities. Concha became almost tender, and if she still held out, it seemed to be half-heartedly, as if in order to avoid breaking the promises that she'd made to herself.

I didn't try to rush her.

When I decided that I ought to settle her mistress-wife's dowry on her in advance, I recalled her reserve the day she'd asked me for this pledge of future constancy. She didn't impose any particular amount on me and so, anxious to avoid disappointing her, I

presented her with five hundred thousand pesetas – which she accepted, moreover, like a bit of loose change.

The weekend was drawing near. I was beside myself with impatience. Never did fiancé long more ardently for his wedding day. Henceforth I need no longer fear her former coquettish ways: she was mine, I'd fathomed her out, and I'd responded to her pure desire for a happy, blameless life. The love that she'd been unable to hide from me during her last night as a dancer was going to be able to express itself freely for many untroubled years to come, and now nothing but joy, utter joy, awaited me in the white bridal house in the calle Lucena.

Just what this joy would be – that's what you're about to find out.

On a whim that I found delightful, she'd expressed the wish to enter her new house – at long last ready for us both – ahead of me and there, all alone, receive me like a secret visitor on the stroke of midnight.

When I arrived, I found the iron gate was barred shut.

I rang. After a few moments Concha came down and smiled at me. She was wearing a plain pink skirt and a small cream-coloured shawl, and had two large red flowers in her hair. In the bright evening light I could make out every detail of her features.

She walked slowly up to the gate, still smiling.

"Kiss my hands," she said.

The gate remained closed.

"Next, kiss the hem of my skirt, and underneath the toe of my slipper."

Her voice seemed radiant.

"Good," she continued, "now go away."

A cold sweat ran down my temples. I felt that I could guess everything that she was going to say and do.

"Conchita, my girl . . . You're joking . . . You're having a laugh . . . Tell me now . . ."

"Oh yes! I'm having a laugh all right! If that's all you want to know, well, I may as well tell you! I'm laughing! I'm laughing! Are you satisfied? I'm laughing with all my heart – listen, just listen how I'm laughing! Ha! Ha! I'm laughing as no-one's laughed since laughter was invented! I'm convulsed, choking, bursting with laughter! You've never seen me so merry! I'm laughing as if I were tipsy! Look at me, Mateo, see how happy I am!"

And she threw up her arms and snapped her fingers like a dancer.

"Free! I'm free of you! Free for the rest of my life! Mistress of my body and of my blood! Oh, don't try to come in – the gate's far too secure! But stay a bit longer. I wouldn't feel happy if I hadn't got everything off my chest."

She moved forward again and spoke to me from close to, in a ferocious voice, her head clamped between her fingernails:

144

"I *loathe* you, Mateo. Words simply cannot express how much I detest you. If you were covered in ulcers, filth and vermin, I couldn't find you more repulsive than I do already when your skin comes near to mine. It's all over now, God willing. I've been running away from you for fourteen months, but you always get me back and every time you touch me, you clasp me in your arms, your lips search for mine . . . Ugh! How it revolts me! At night I used to spit each of your kisses out onto the floor. You'll never know how my flesh crept when you climbed into my bed! Oh, how I've hated you! How I've prayed to God, that He might turn against you! I've received Holy Communion seven times since last winter, so that you might die the day after being ruined by me. Let it be as God wills! I no longer care – I'm free! Now go away, Mateo. I've done."

I stood there, as if turned to stone.

"Go away!" she repeated. "Haven't you understood?"

Then, as I could neither speak nor move, for my mouth had gone dry and my legs seemed frozen to the spot, she sprang back towards the staircase, and her eyes blazed with a kind of fury.

"So you won't go away!" she shouted. "You won't go away? Right then, I'll show you!"

And with a cry of triumph, she called out:

"Morenito!"

My arms were trembling so much that I was shaking the bars of the gate around which my fists were clenched.

There he was. I watched him come down.

Throwing back her shawl, she opened her bare arms wide to greet him.

"Here he comes – my lover! See how handsome he is! And how young, Mateo! Watch me carefully now. How I adore him! ... Come, my little darling, give me your lips! ... Once more ... And again ... Longer ... How sweet life is! Ah! I'm so in love! ..."

And that's not all she was saying to him ...

Finally ... as if she deemed my torment insufficient ... she ... I can hardly bring myself to tell you, sir ... she joined with him ... there ... in front of me ... right before my very eyes ...

I can still hear, like the buzzing of an insect in its death throes, the moans of pleasure that made her mouth tremble even as mine gasped for air – and also the tone of her voice when, as she went back upstairs with her lover, she threw this final phrase at me:

"It's my guitar, and I'll play it for whoever I like!"

HOW MATEO RECEIVED A VISIT, AND WHAT ENSUED

If I didn't kill myself on returning home, it must have been because over and above my tortured existence an anger yet more powerful sustained and counselled me.

Incapable of sleeping, I didn't even go to bed. Daybreak found me on my feet, in this very room, pacing up and down between the windows and the door. As I passed in front of a mirror, I saw without surprise that I'd gone grey.

In the morning I was served a plain breakfast at a table in the garden. I'd been there for ten minutes, neither hungry, nor thirsty, nor even thinking, when, coming towards me from the far end of a garden path, almost like something out of a dream, I saw . . . Concha.

Oh, don't be surprised! Nothing can be ruled out when talking of her. Her every action is always, without fail, both astounding and vile. As she drew nearer to me, I was anxiously asking myself just what selfish urge could be driving her on – the desire to gaze once more upon her triumph, or the feeling that she might perhaps, by a daring manoeuvre, and to her own advantage, complete my material ruin? Either explanation was equally plausible.

She leaned slightly to one side in order to pass beneath a branch, then folded her parasol and her

fan, and sat down in front of me, with her right hand resting on the table.

I remember that behind her there was a flowerbed, with a slender, gleaming spade stuck in the soil. During the long silence that followed, I was possessed by an overwhelming temptation to grab hold of the spade, fling the woman onto the ground, and chop her in two like a common earthworm . . .

"I came," she said at last, "to find out how you'd died. I thought that you really loved me, and that you'd have killed yourself during the night."

Then she poured the chocolate out into an empty cup and raised it to her quivering lips, adding, as if to herself:

"Not cooked enough. It tastes horrible."

When she'd finished, she stood up, opened her parasol, and said:

"Let's go inside. I've been keeping back a surprise for you."

"So have I," I thought.

But I said nothing.

We went up the steps to the verandah. She ran on ahead, singing an aria from a well-known Spanish operetta with a deliberation doubtless intended to make me feel the allusion more keenly:

> *"And what if I didn't want you*
> *To go around with your arm in his?*
> *– Then I'd go with him to the fair*
> *And to the bullfight at Carabanchel!"*

Of her own accord she went into one of the rooms . . . I didn't push her in there, sir . . . Nor did I wish for what happened next . . . But such was our common destiny . . . What had to be, had to be.

The small room she'd entered – I'll show you it shortly – has carpets hanging everywhere, and is muffled and gloomy like a tomb, with no furniture other than a few couches. I used to go there to smoke. It's abandoned now.

I followed her in. I closed and locked the door without her hearing. Then the blood – the anger that had been building up inside me day after day for fourteen months – rushed to my head and, turning towards her, I gave her a slap in the face that stunned her.

It was the first time that I'd struck a woman, and it left me as shaken as it did Concha, who'd leapt backwards, seemingly bewildered, her teeth chattering . . .

"You . . . Mateo . . . You did that to me . . ."

And, amid a violent stream of abuse, she cried out:

"Don't worry! You shan't so much as lay another finger on me!"

She was already searching in her garter, where so many women keep a small weapon concealed, when I crushed her hand and threw the dagger up onto a canopy that was almost as high as the ceiling.

Then, holding both her wrists in my left hand, I forced her to her knees.

151

"Concha," I said, "I'm going neither to insult you nor to upbraid you. But listen carefully. You've made me suffer beyond the limits of human endurance. You've devised moral torments in order to inflict them on the only man who's ever loved you passionately. And I hereby declare that I'm going to have you right now, by force if necessary, and not just once, do you hear, but as many times as I care to before nightfall."

"Never!" she cried. "I'll never be yours. I loathe you, I've told you so. I hate you! I hate you worse than death itself! So go ahead and murder me then! You shan't have me any other way!"

It was then that I silently began to hit her . . . I'd gone completely mad . . . I don't really know what happened next . . . I couldn't see properly . . . I couldn't think straight . . . All I can remember is that I hit her with the regularity of a peasant wielding a flail – and always on the same two spots: the left shoulder and the top of the head . . . I've never heard such terrible screams . . .

This went on for perhaps a quarter of an hour. She didn't say a word, either to beg for mercy or to surrender. I stopped when my fist began to ache, and then I let go of her hands.

She sank down on one side, her arms stretched out in front of her, her head thrown back, her hair dishevelled, and her screams suddenly turned into sobs. She cried like a little child, always at the same pitch, and going for as long as she could without drawing a breath. At times I thought that she was choking. I can still see the movement she incessantly made with

her bruised shoulder, and her hands in her hair,
removing the pins . . .

Then I felt so sorry for her, and so ashamed of
myself, that for a while I almost forgot the ghastly
scene of the night before . . .

Concha had picked herself up somewhat: she was
still kneeling, with her hands up by her cheeks, and
her eyes raised towards me . . . and in those eyes,
there no longer seemed to be the slightest hint of
reproach, but rather . . . I don't quite know how to
put it . . . a kind of adoration . . . At first her lips
were trembling so much that she couldn't articulate
properly . . . Then I faintly made out:

"Oh, Mateo! How you love me!"

She came closer, still down on her knees, and
murmured:

"Forgive me, Mateo! Forgive me! I love you
too . . ."

She was being sincere, for the first time. But I no
longer believed her.

"How well you've beaten me, my love!" she went
on. "How sweet it was! How good . . . Forgive me for
everything that I've done to you! I was mad . . . I
didn't know . . . Have you really suffered so for me,
then? Forgive me, Mateo! Forgive me! Forgive me!"

And she added, in the same gentle voice:

"You shan't have me by force. I'm ready for you.
Help me get up. Did I say that I had a surprise for
you? Well, you'll soon find out what it is: I'm still a
virgin. Yesterday's scene was just play-acting, to
make you suffer. For I can tell you now that, until

today, I didn't care for you much. But I'm far too proud to go with someone like Morenito ... I'm yours, Mateo. I'll be your wife this very morning, God willing. Try to forget about the past and to understand my poor little soul instead, for I can't make head or tail of it. I feel like I'm waking up. I see you as I've never seen you before. Come to me."

And what's more, sir, she was indeed a virgin ...

CHAPTER FOURTEEN

IN WHICH CONCHA CHANGES HER WAY OF LIFE, BUT NOT HER CHARACTER

This would make a good ending to a novel, and with such a conclusion all would be well that ended well! Alas! That I could but stop there! Perhaps you'll find out for yourself some day that, in the course of a human existence, no misfortune is ever wiped out, no wound ever heals up, and no woman will ever be capable of cultivating happiness in the same devastated field in which she has sown tears and anguish.

Not long after that particular morning – it was a Sunday evening, about a week later – Concha came home a few minutes before dinner, saying:

"Guess who I've seen! Someone I'm very fond of . . . Think now . . . I was so pleased."

I remained silent.

"I saw Morenito," she went on. "He was walking along Las Sierpes, in front of Gasquet's store. We went to the Cervecería together for a drink. You know, I spoke ill of him to you; but I haven't told you all that I think. He's good-looking, is my little friend from Cadiz. But you know that already; you've seen him. He has bright eyes with long eyelashes – and how I adore long eyelashes! They give such depth to one's expression! And then, he doesn't have a moustache, his mouth is well-formed, his

teeth are white ... All the women run the tips of their tongues over their lips when they see how nice he is."

"You're joking, Conchita ... It's not possible ... Tell me now: you didn't see anyone, did you?"

"Ah! So you don't believe me then? Just as you please ... In that case, I'll never tell you what happened next."

"Tell me immediately!" I shouted, grabbing her by the arm.

"Oh! Don't lose your temper! I'll tell you! Why should I make a secret of it? I take my pleasure where I find it. We went a little way out of town together, *along a little path, so bright, so bright, so bright* to the Cruz del Campo. Need I go on? We looked at all the rooms, in order to find the one with the best bed ..."

And as I started to my feet, she concluded from behind her protecting hands:

"Come now, it's only natural. His skin is so soft, and he's so much better-looking than you are!"

What could I do? I hit her again. Brutally, unsparingly, so that I felt disgusted with myself. She screamed, she sobbed, she prostrated herself in a corner, with her head on her knees, wringing her hands.

And then, as soon as she was able to speak again, she said to me in a tearful voice:

"It wasn't true, my love ... I went to the bullfight ... I spent the day there ... my ticket's in my pocket ... take it ... I was alone with your friend G ... and

his wife. They spoke to me, they'll tell you . . . I saw all six bulls get killed, and I didn't leave my seat and I came straight home afterwards."

"But then, why did you say . . .?"

"So that you'd beat me, Mateo. When I feel your strength, I love you, I really love you – you can't imagine how happy it makes me to weep because of you. Come here now. Make me well again, quick."

And that's how it was, sir, right to the very end. Once she'd become convinced that I was no longer taken in by her false confessions, and that I'd every reason to believe in her fidelity, she invented new pretexts for provoking me to daily outbursts of anger. And in the evening, in those circumstances in which all women repeat: "You'll always love me, won't you?", I had to listen to such astounding but genuine phrases (and I'm not making this up) as: "Mateo, will you beat me again? Promise that you'll give me a good beating! That you'll kill me! Tell me that you'll kill me!"

Don't go thinking, however, that her character was entirely built around this strange predilection. Oh no! If she felt a need for punishment, she also had a passion for transgression. She did wrong not because sinning gave her pleasure, but because she delighted in hurting people. Her purpose in life was limited to sowing seeds of suffering and watching them grow.

To begin with there were fits of jealousy such as you cannot possibly imagine. She spread such rumours about my friends and about everyone that made up my circle, and if need be showed herself

personally so insulting, that I broke with all of them and soon found myself alone. The mere sight of another woman, whoever she might be, was enough to send her into a rage. She dismissed all my female servants, from the poultry girl right up to the cook, although she knew perfectly well that I never even spoke to them. Then, in just the same manner, she drove away those that she herself had chosen. I was forced to change all my suppliers, because the hairdresser's wife was blonde, because the bookseller's daughter was dark-haired, and because the woman who sold cigars used to ask for my news when I went into her shop. Before long, I gave up going to the theatre for, indeed, if I looked at the audience, it was to feast my eyes on some woman's beauty, and if I looked at the stage, it was conclusive proof that I was falling in love with one of the actresses. I stopped going for walks with her in public for the same reasons: the slightest greeting became, in her eyes, a sort of declaration of love. I could neither leaf through a set of engravings, nor read a novel, nor look at an image of the Virgin Mary, lest she accuse me of being infatuated with the model, the heroine, or the Madonna. I always gave in, so greatly did I love her. But after what tiresome fights!

At the same time as I was thus feeling the effects of her jealousy, she was endeavouring to keep mine alive by means that, though contrived to start with, later on became real.

She deceived me. From the care that she took to

inform me of the fact, I could tell that she was more interested in arousing my emotions than her own. All the same, even morally speaking, it was hardly a valid excuse; and, in any case, when she got home from these affairs of hers, I was in no fit state to start justifying them, as I'm sure you'll understand.

Soon it was no longer enough for her to bring me back the proofs of her infidelities. She wanted to repeat the scene at the gate, but this time without any faking. That's right! She was scheming against herself, in order to be caught in the very act!

It took place one morning. I awoke late. She wasn't there at my side, but on the table there was a letter, which ran as follows:

'To Mateo, who no longer loves me! – I got up while you were asleep and I've gone to meet my lover at the Hotel X . . ., room 6. You can kill me there if you wish; the door won't be locked. I'm going to prolong my night of love until the end of the morning. So come along! If I'm lucky, you might perhaps catch me in a close embrace.

Your adoring,
CONCHA.'

I went there. My God, what a morning that was! A duel followed. It caused a public scandal. You may have heard about it.

And when I think that all this was done to "bind me closer" to her! How women can be blinded by their imaginations when it comes to men's love!

What I saw in that hotel room lived on thereafter,

forming a kind of impenetrable veil between Concha
and me. Instead of exciting my desire, as she'd
hoped, the memory of it actually seemed to coat and
permeate her entire body with something odious,
that wouldn't go away. I took her back, however;
but my love for her had suffered a mortal blow. Our
quarrels became more frequent, more bitter – more
violent as well. She clung to my existence with a kind
of frenzy, out of sheer egoism and selfish passion.
Her fundamentally evil soul didn't even suspect that
one could love in any other way. She wanted at all
costs – whether by fair means or foul – to keep me
locked in her embrace. In the end I broke free.

It happened quite suddenly one day, after yet
another of our many rows, simply because it was
inevitable.

A little gypsy girl, a basket-seller, had come up the
garden steps to offer me her humble wares, made of
reeds and woven rushes. I was just going to give her
some money, out of charity, when I saw Concha rush
towards her and tell her, extremely abusively, that
she'd already called by the month before, and that
she doubtless intended offering me much more than
her baskets, adding that one could tell very well from
her eyes what her real profession was, that if she
walked around barefoot it was to show off her legs
and that she must be shameless indeed to go thus
from door to door, wearing a petticoat that had obvi-
ously got torn while hunting for lovers. All of this
was said with the utmost disdain, and peppered with
outrageous insults that don't bear repeating. Then

she snatched the girl's goods from her, broke them all into pieces, and trampled them underfoot. You can just imagine how the poor little thing wept and trembled. I compensated her, of course. Which provoked a battle.

That day's row was neither fiercer nor more tiresome than any of the others; yet it was final. I still don't know why. "You're leaving me for a gypsy!" – "Not at all. I'm leaving you to get some peace."

Three days later I was in Tangiers. She caught up with me. I left with a caravan for the interior, where she couldn't follow me, and for several months I remained without news from Spain.

When I got back to Tangiers, I found fourteen letters waiting for me at the Post Office. I took a steamer to Italy, where I received a further eight letters. Then nothing.

I only returned to Seville after a year spent travelling. She'd got married a fortnight before to some young fool – of noble birth, moreover – that she then lost no time in having sent out to Bolivia. In her last letter to me, she said: "I'll be yours, and yours alone – otherwise I'll let whoever wants me, have me." I imagine that she's busy keeping the latter promise.

That's all I had to say, sir. Now you know who Concepción Pérez is.

As for myself: crossing her path has ruined my life. I expect nothing more from her now, except to be forgotten. But such hard-won experience can and should be passed on in the event of danger. Don't be surprised if I've made such a point of talking to you

in this way. The Carnival died yesterday; real life begins anew. For your sake I've briefly raised the mask of an unknown woman."

"I'm very grateful," said André solemnly, shaking him by both hands.

CHAPTER FIFTEEN

WHICH IS THE EPILOGUE AND ALSO THE MORAL OF THIS STORY

André walked back towards town. It was seven o'clock in the evening, and the earth's metamorphosis was imperceptibly drawing to its close in enchanted moonlight.

To avoid returning the way he had come – or for some altogether different reason – he took the Empalme road, after a long detour across country.

The inexhaustible heat of the south wind, more voluptuous than ever at this already nocturnal hour, intoxicated him.

As he paused, with his eyes nearly closed, to enjoy the thrill of this novel sensation, a carriage coming the other way went past him, and then pulled up abruptly.

He moved forward: someone was speaking to him.

"I'm a little bit late," murmured a voice. "But you're kind, and you've waited for me. O handsome stranger – you attract me; but ought I to put my trust in you on this dark, deserted road? Ah, Lord! You see, I really don't feel like dying this evening!"

André threw her a glance that took in an entire destiny. Then, suddenly turning very pale, he climbed into the empty seat beside her.

The carriage drove away, deep into the countryside, until it came to a small green house that stood

in the shade of three olive trees. The horses were unharnessed. They slept. Next day, towards three o'clock, they were harnessed up again, and the carriage set off for Seville, drawing up outside number 22, Plaza del Triunfo.

Concha was the first to alight. André followed. They went in together.

"Rosalia!" she called out to a chambermaid, "Pack my bags, quickly! I'm leaving for Paris."

"A gentleman called to see you this morning, ma'am, and was most insistent that he be let in. I don't know who he is, ma'am, but he said that he was an old acquaintance, and that he'd be extremely happy if you'd deign to receive his visit, ma'am."

"Did he leave his card?"

"No, ma'am."

But just then a servant appeared, bearing a letter, and André later learned that it ran as follows:

'*My darling Conchita, I forgive you. I cannot live where you are not. Now I'm the one who's down on his knees, beseeching you to come back.*

I kiss your bare feet.

MATEO.'

Seville, 1896.
Naples, 1898.